Merry Vintage Christmas Coloring Book

By Cheryl Korotky

The World of Enchanted Imagination

Hello Fellow Colorist

Welcome to

"The World of Enchanted Imagination" by Cheryl Korotky.

When I was a little girl I used to watch my grandmother color enhancing old B&W family photos. The work Nana produced was beautiful! She loved adding colorful life to otherwise, drab and badly faded memories. She used a variety of mediums, including colored pencils, watercolor and even crayons. When Nana was finished, she would frame the print and proudly display her new trophy for all to admire.

It was these cherished memories from my childhood, as well as the growing adult coloring trend that gave me the idea of producing high-quality, grayscale picture/coloring books. These will probably differ from what you are accustom to working with. I want to offer people the opportunity to produce genuine works of art; pictures of "REAL" animals, people, nature, etc. as well as Fantasy!

Grayscale is like a guide to help you along. You simply follow the natural shading. Completed projects are breathtaking, although there sometimes may be a learning curve like with any new skill, but practice makes perfect! There are some people who ONLY color grayscale! I hope you will become one of them. I occasionally see negative reviews on my fellow grayscale authors' pages mentioning the pictures were just regular photos made B&W. Well, exactly! That's what grayscale is!

Please join my Enchanted Imagination Grayscale Coloring Group at:

https://www.facebook.com/groups/1296319000437408/

Together we can grow and help each other with positive encouragement. This is the page where you can share your completed work from The World of Enchanted Imagination coloring books. Looking forward to seeing you there...

HAPPY COLORING!

BASIC INSTRUCTIONS

This book is produced though **KDP**, which means the paper will be of medium weight and good for colored pencils. That being said, I ask you to please follow some simple and basic instructions so you will enjoy your coloring experience.

- If possible, watch some grayscale tutorials online. It will make a difference. The education is invaluable and there are so many exceptional coloring artists that can help guide your journey to achieve beautiful pictures. As you continue to color, the more grayscale you do, the better your pictures will become. Be aware, for most people there is definitely a learning curve when first discovering grayscale but the end results are worth it.

- Try choosing about 3 or more colors in the same hue for each section you are working on. Follow along the naturally occurring shadows of the grayscale. Have some scrap paper next to you so you can try the colors you are using and how well they blend and complement each other. Colored pencils do not erase well (some not at all) so it's better to discover that the two greens don't blend well together on scrap paper then on your artwork.

- Always put at least a piece of paper but best to use cardstock or cardboard between your pages as you are working. This will help prevent bleed-through as well as pressure transfer to your other pictures. You may also cut the pictures out with an exacto knife or scissors. If you prefer using a wet medium, I suggest copying on alternative, high quality paper because from my understanding through word of mouth, the paper is good and handles colored pencils easily but not thick enough to accommodate anything that can be readily absorbed. Pictures may only be reproduced for your own use!

- Great coloring art is created by using several layers of color and blending. Start out light and keep adding more. Different pressure levels are also helpful. Keep trying different mediums to discover what you like. My personal favorites are colored pencils, watercolor pencils and gel pens. Don't forget to join my coloring group. I can't wait to see your completed work!

https://www.facebook.com/groups/1296319000437408/

Practice! Practice! Practice! The more grayscale you do, the better your results will be.

Cheryl Korotky grew up in Port Jervis, NY and received her very first camera at the age of 10. She started taking pictures of family, friends and the family cat and has been hooked ever since. Now a professional, multi-award winning photographer and proprietor of **A Heartbeat in Time Photography**, her specialties include child photography and B&W/grayscale.

Discover her work at:

https://www.facebook.com/AHeartbeatInTimePhotography

Also on Pixoto where you can see her awards for **Top Photographer of the Year** in **Babies & Children** and **B&W**:

http://www.pixoto.com/cheryl.korotky/recent

Come join our coloring group, The World of Enchanted Imagination Coloring where we encourage you to share & celebrate your completed artwork from our books.

https://www.facebook.com/groups/1296319000437408/

When Cheryl is not taking pictures (her family affectionately calls her, "The Paparazzi"), you can find her exercising, gardening, cooking, teaching, reading, writing, painting or coloring. An avid nature-lover, she makes her home in the mountains of NE Pennsylvania (Equinunk) with her family and various pets and wildlife.

She is currently working on several grayscale coloring books for **The World of Enchanted Imagination,** many now already in print. Also, she will be publishing a group of children's books from **The Stories Your Child Will Actually Want to Read** series as well as several novels in the works. Watch for her upcoming books.

This book is dedicated to my grandmother, Gladys Wickham, who taught me the joy of seeing the world in color. Also, to my entire family and daughters, Tracy Dupre, Chelsea Wells, as well as my 4 grandchildren, Nevaeh & Peyton Wells, Adam Dupre & Grayson Kramer.
 And last but not least, to my fiance, Frederick Peckham, who always believes in me and all my endeavors.

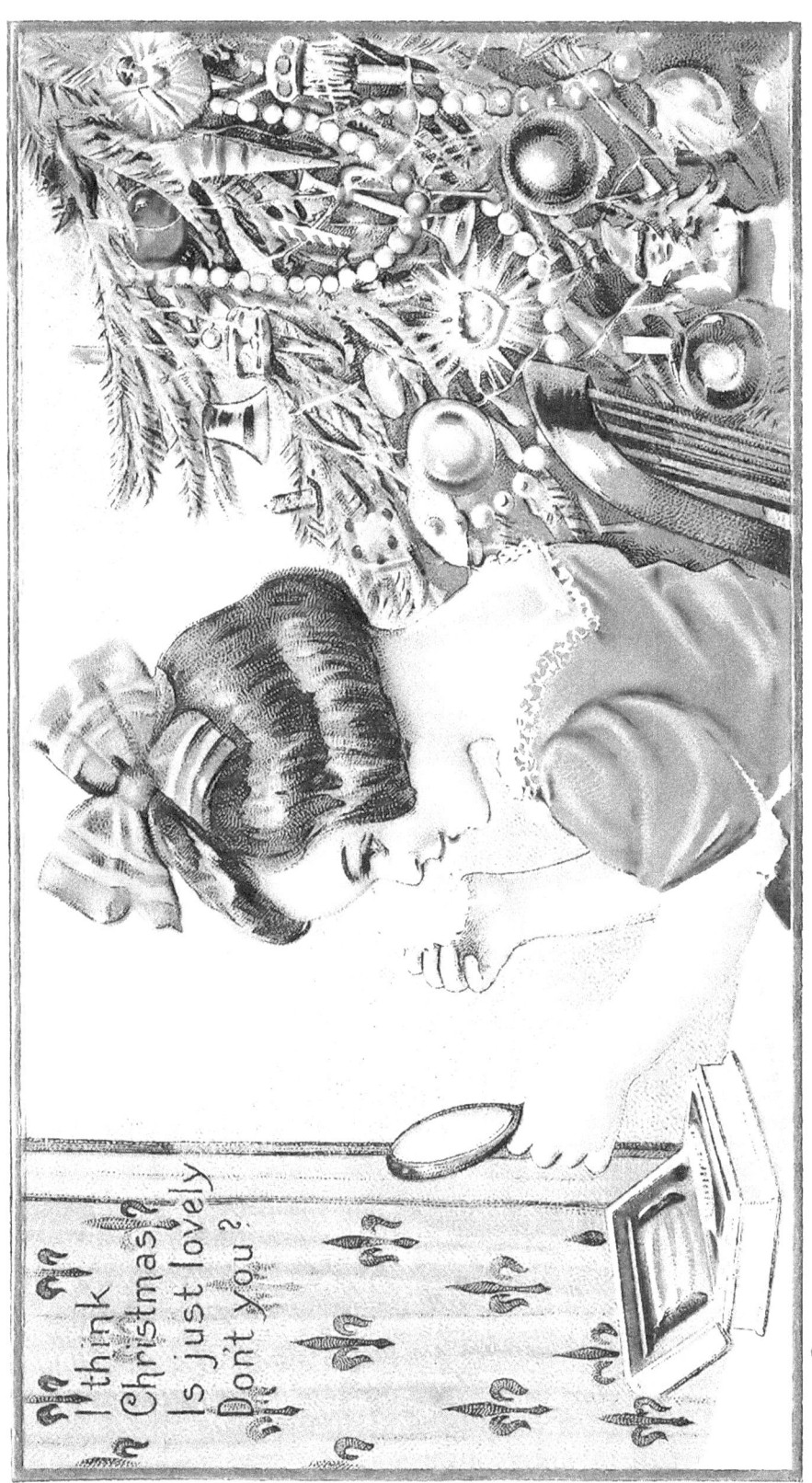

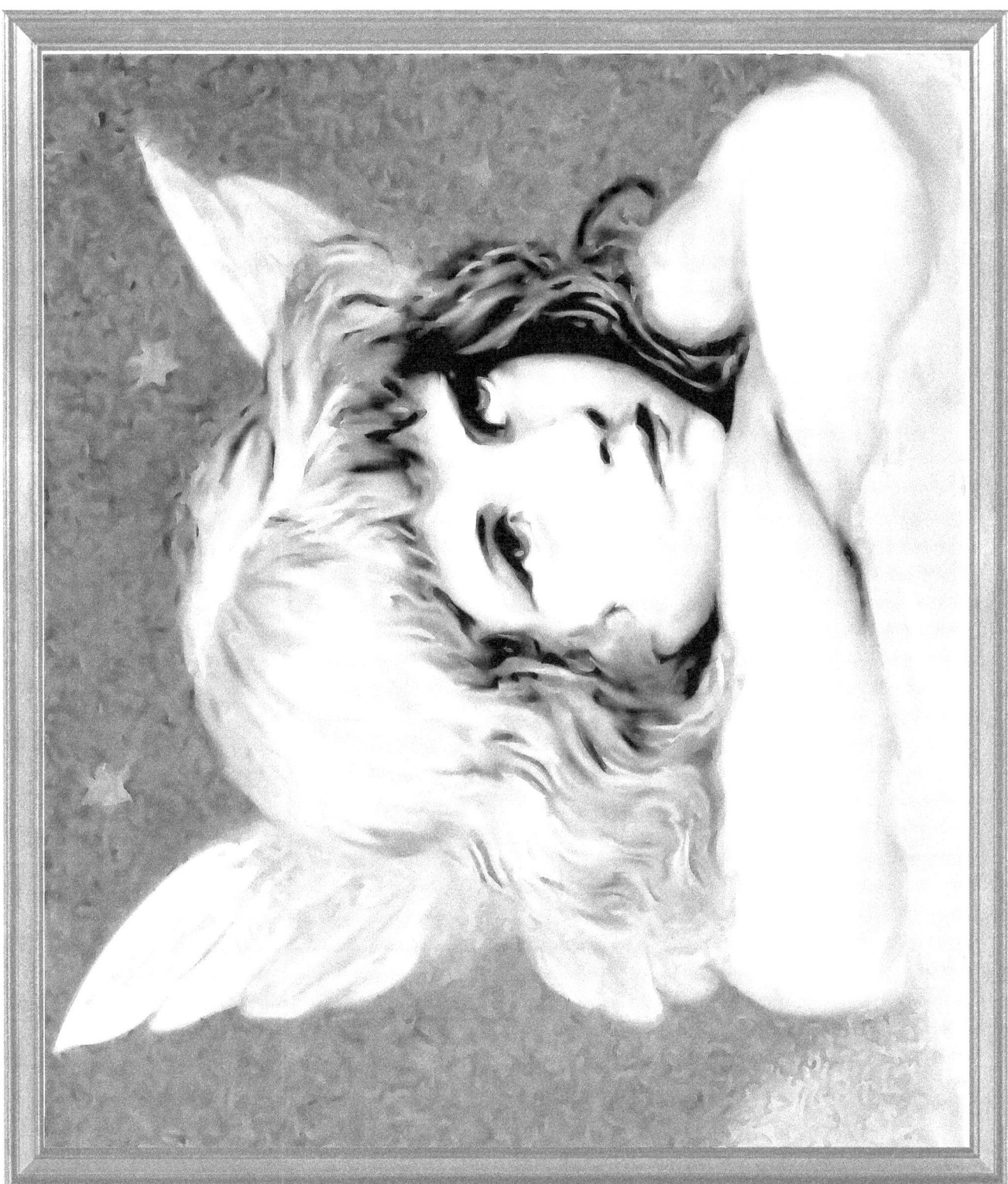

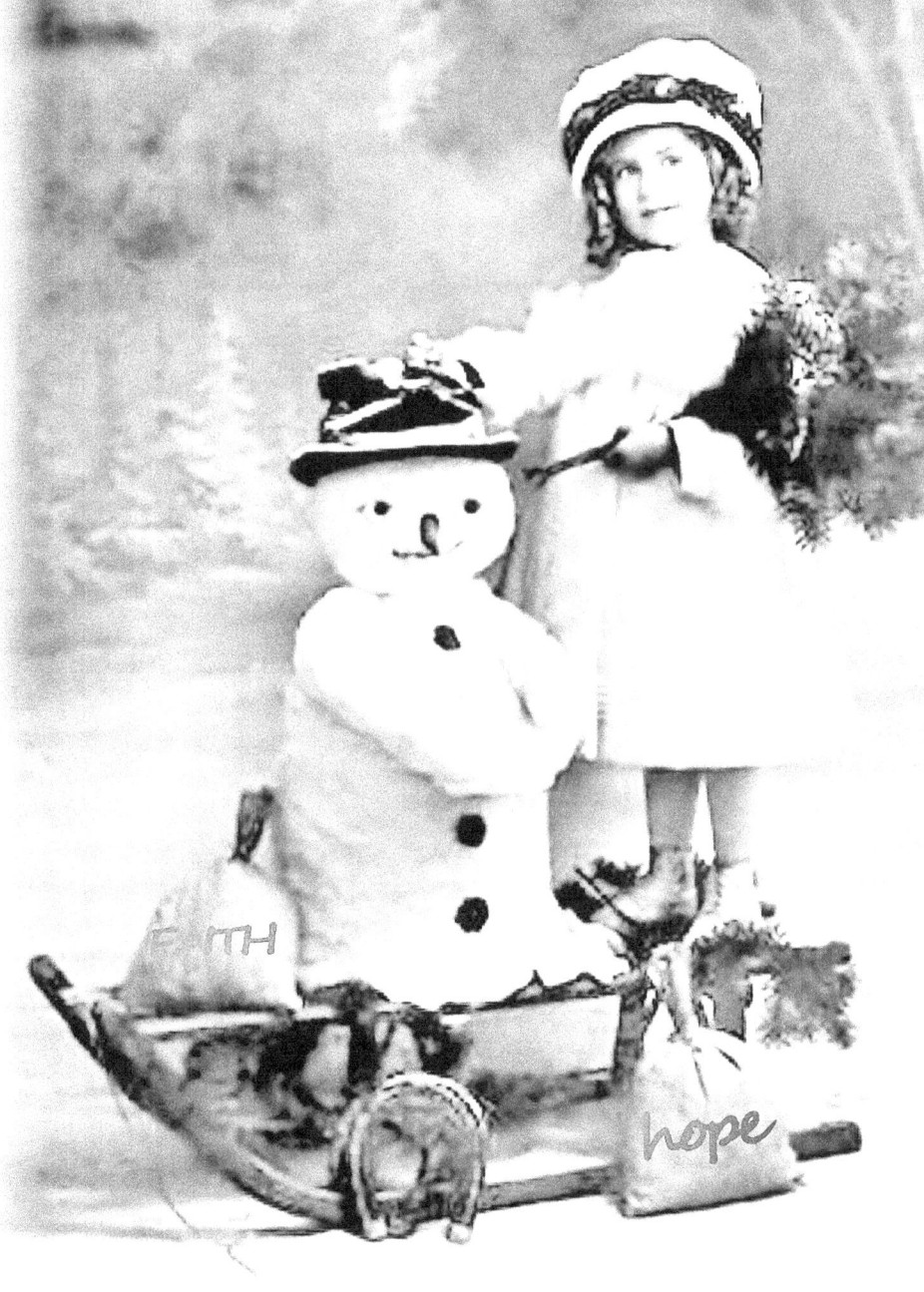

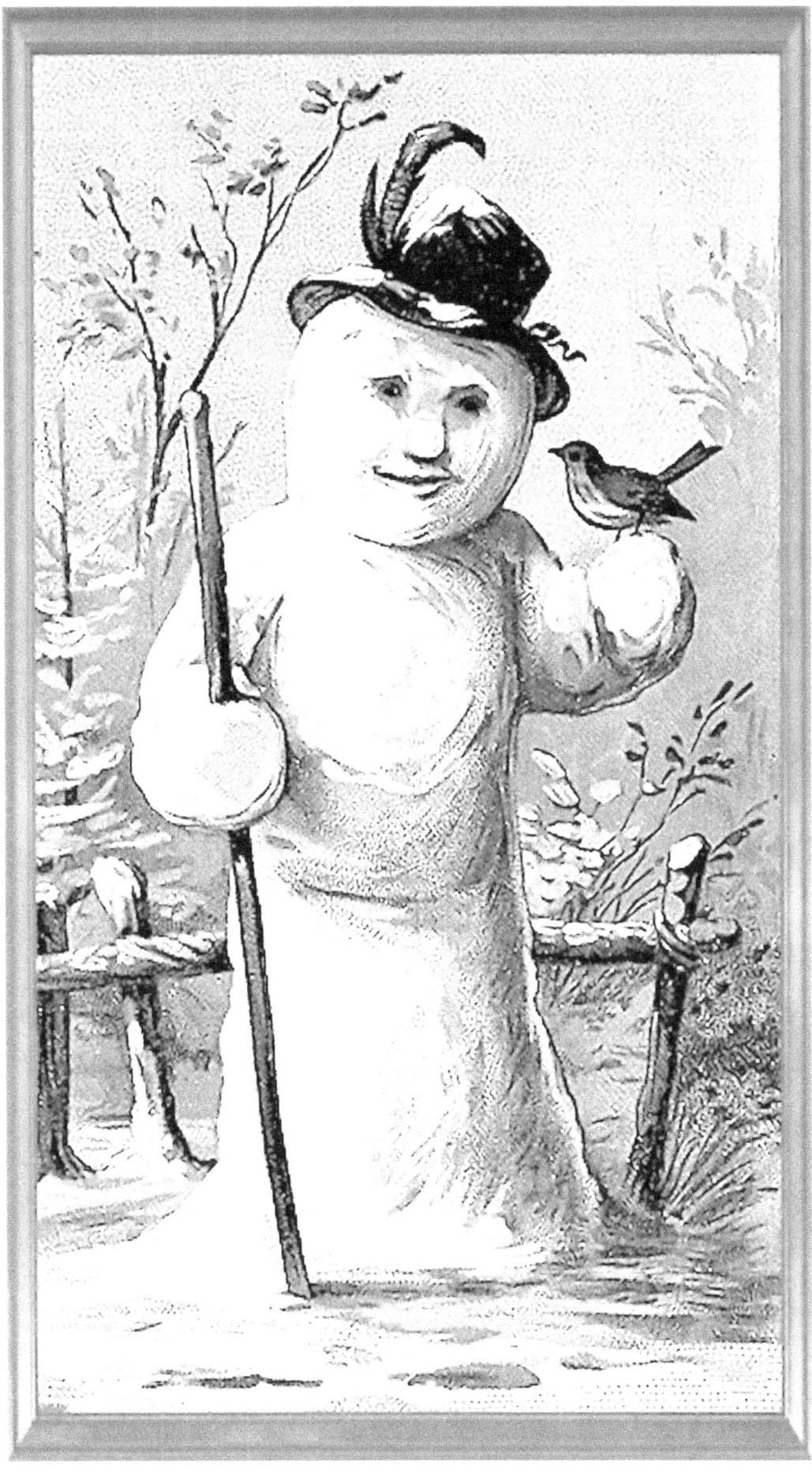

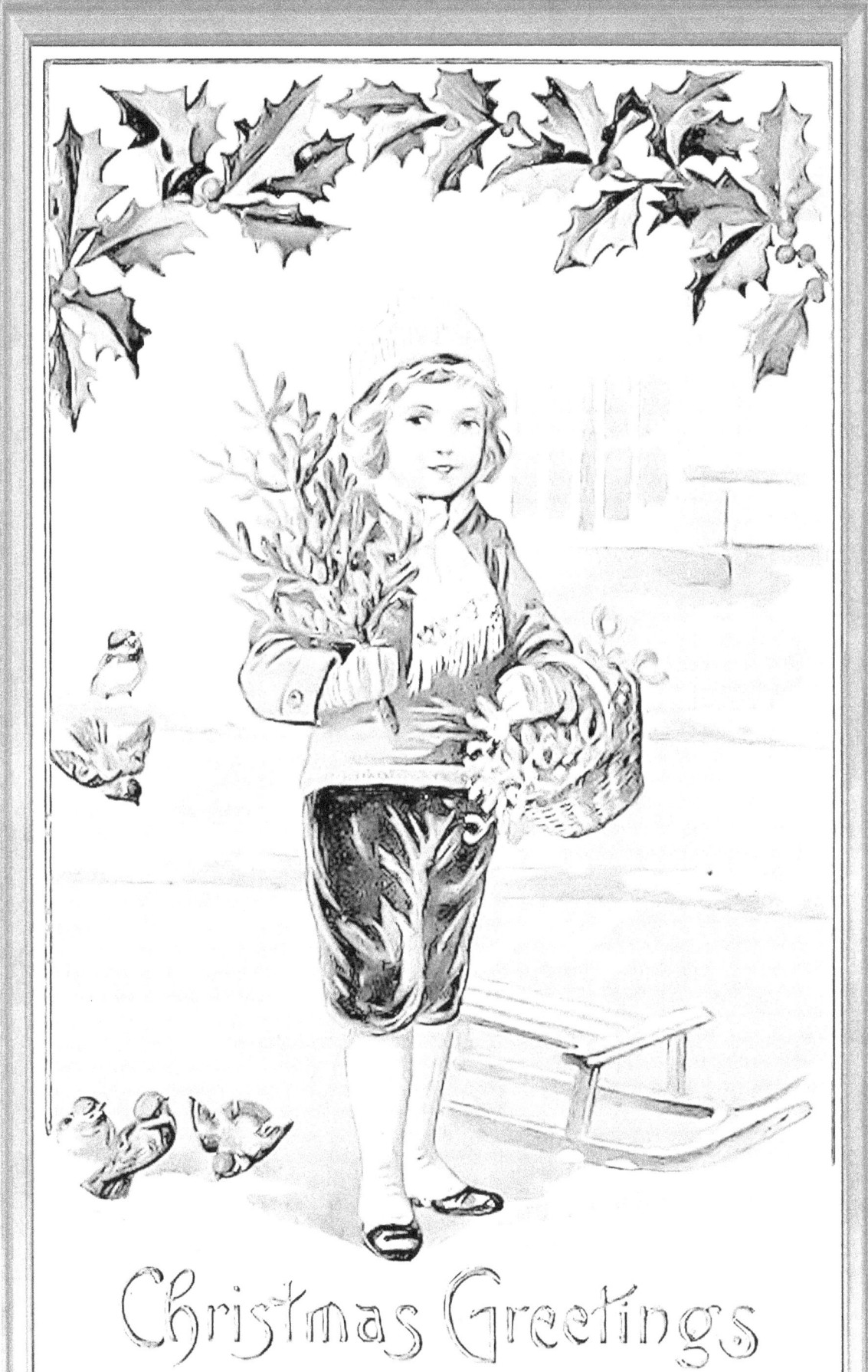

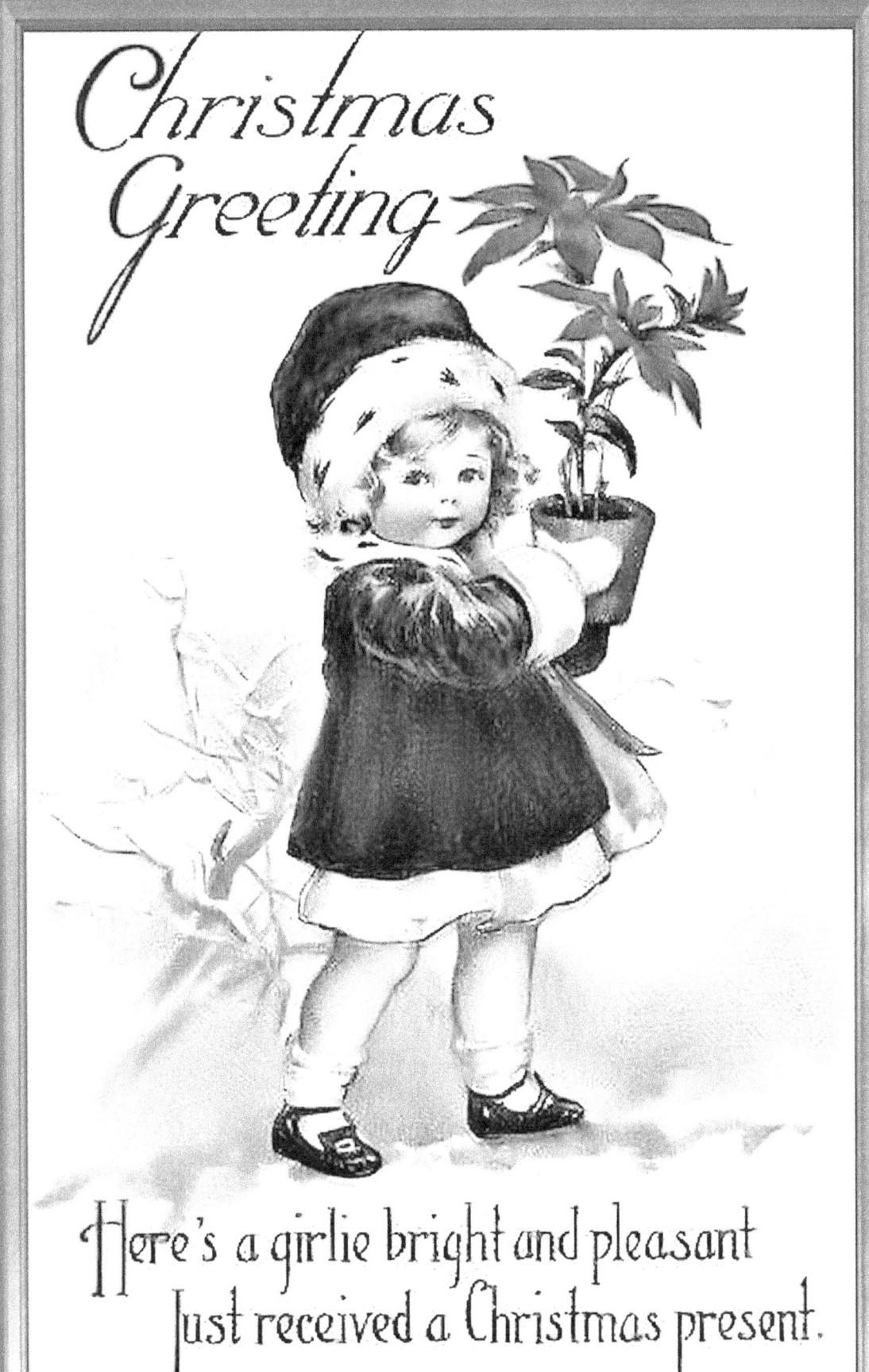

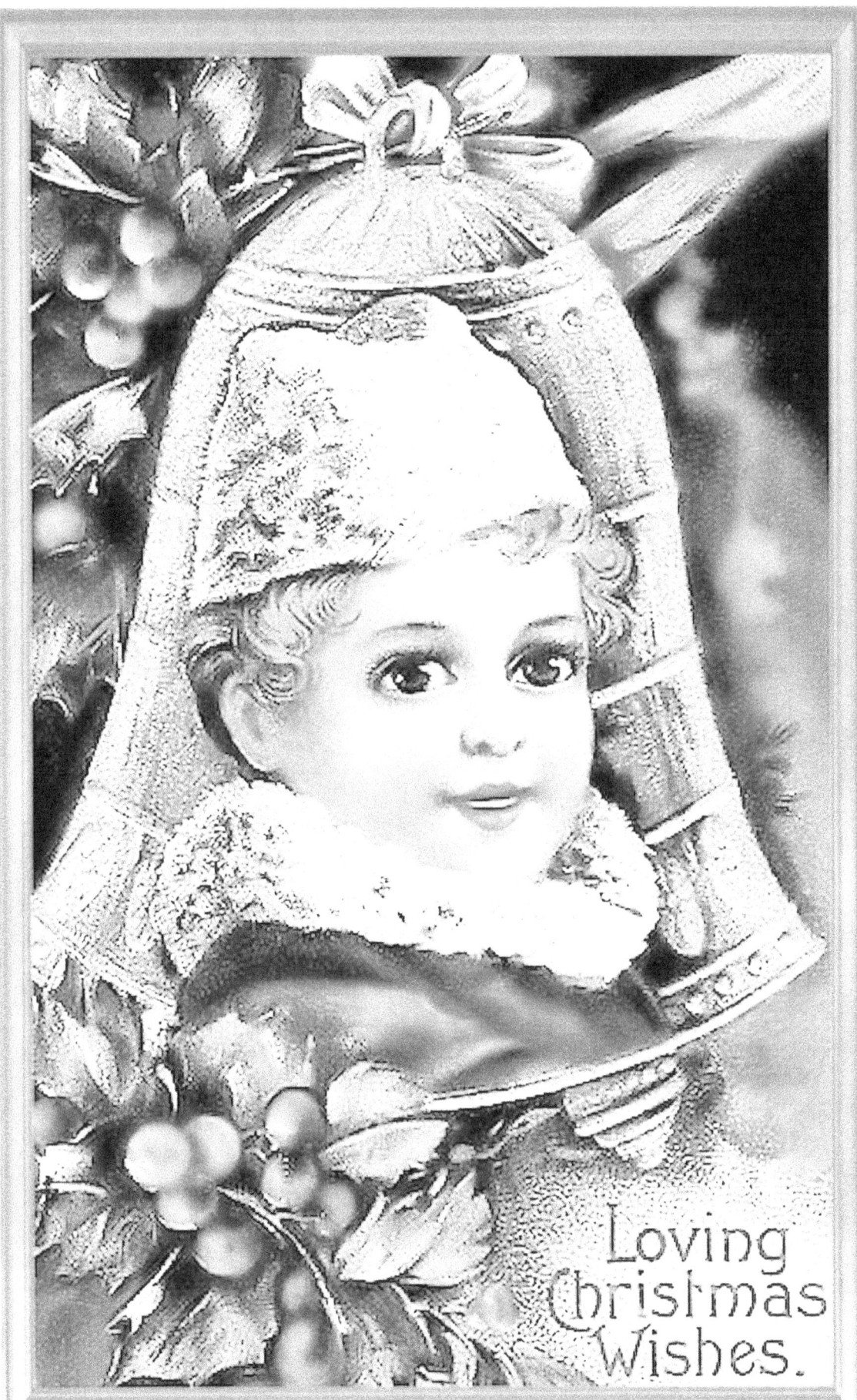

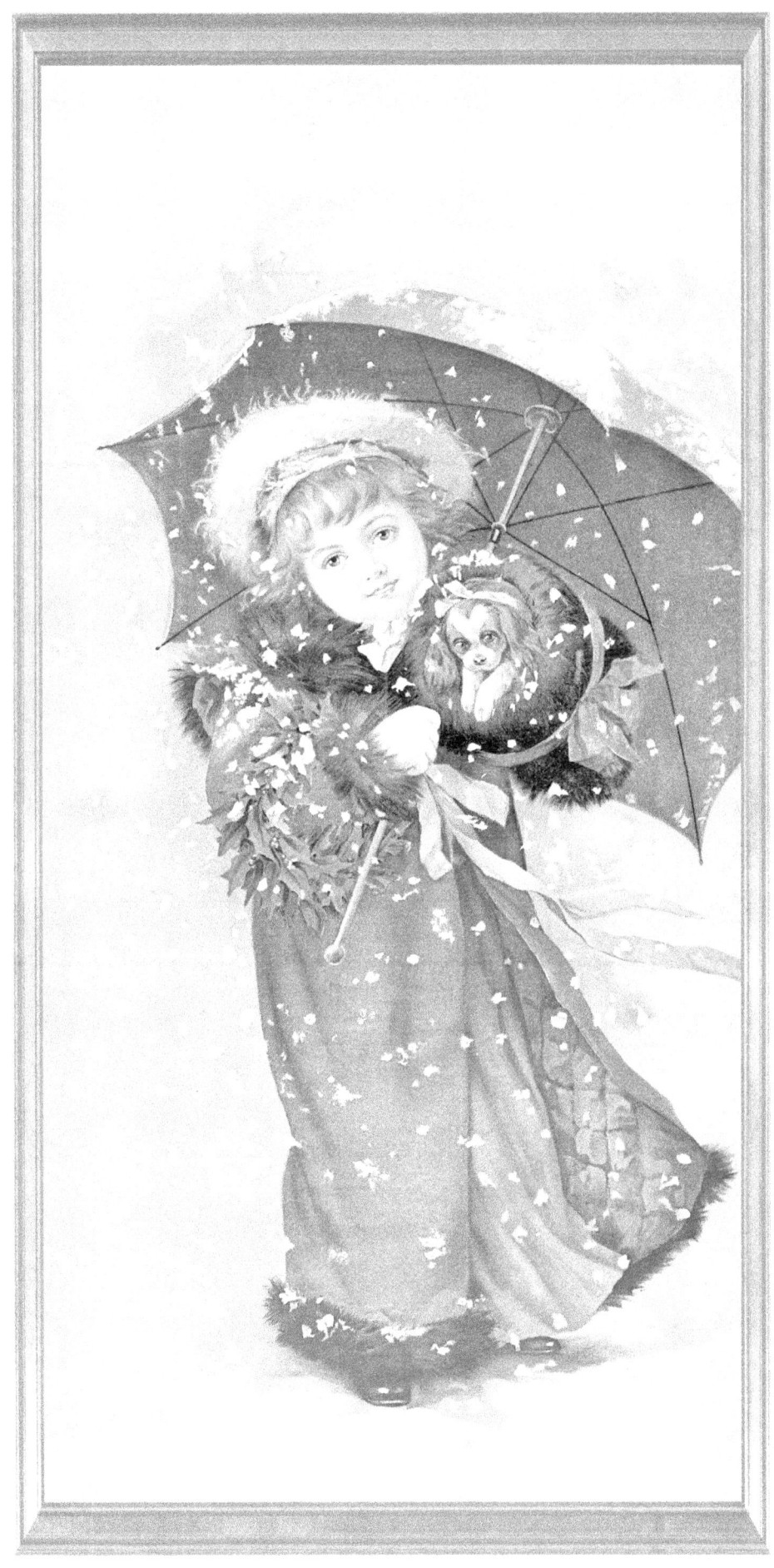

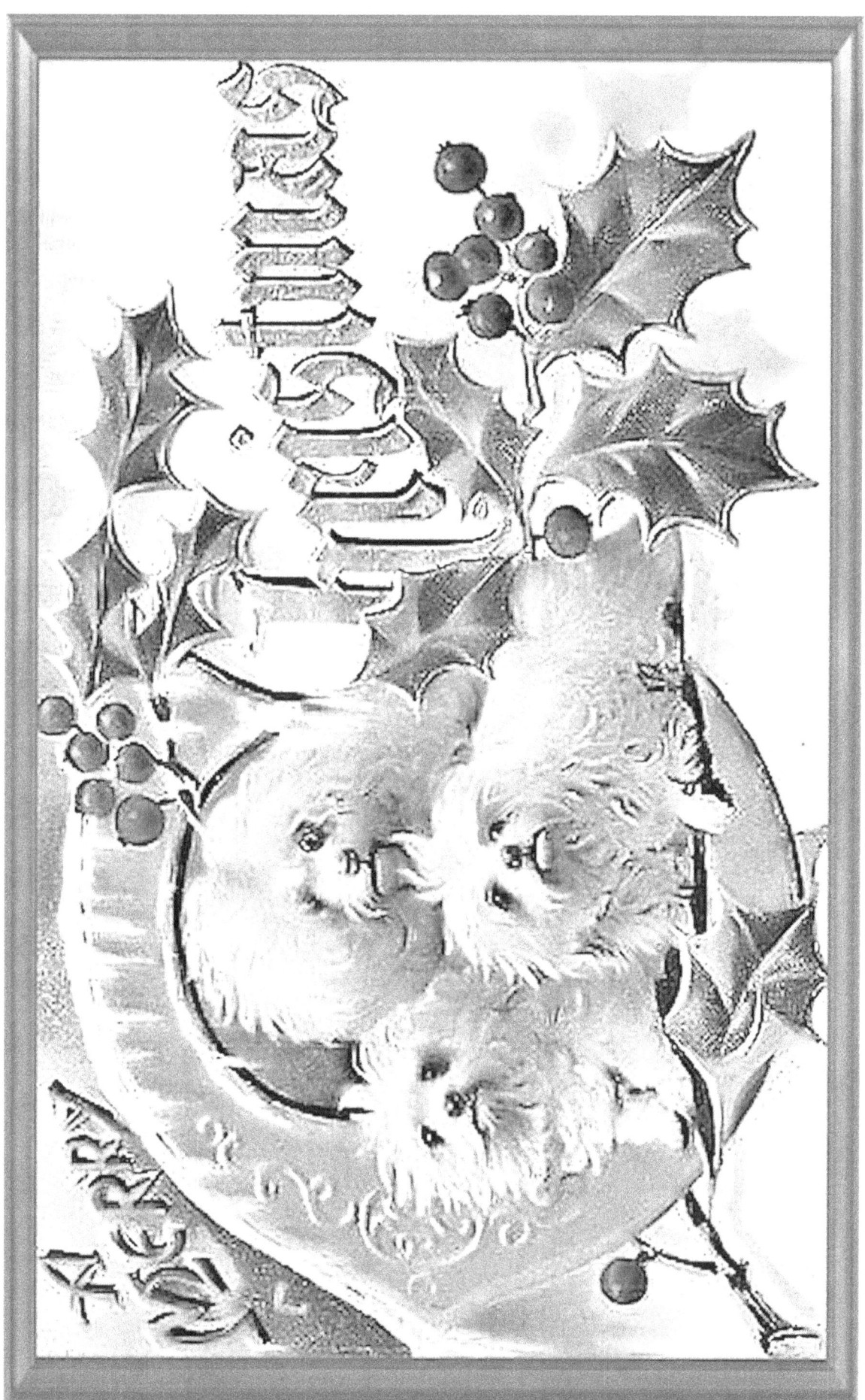

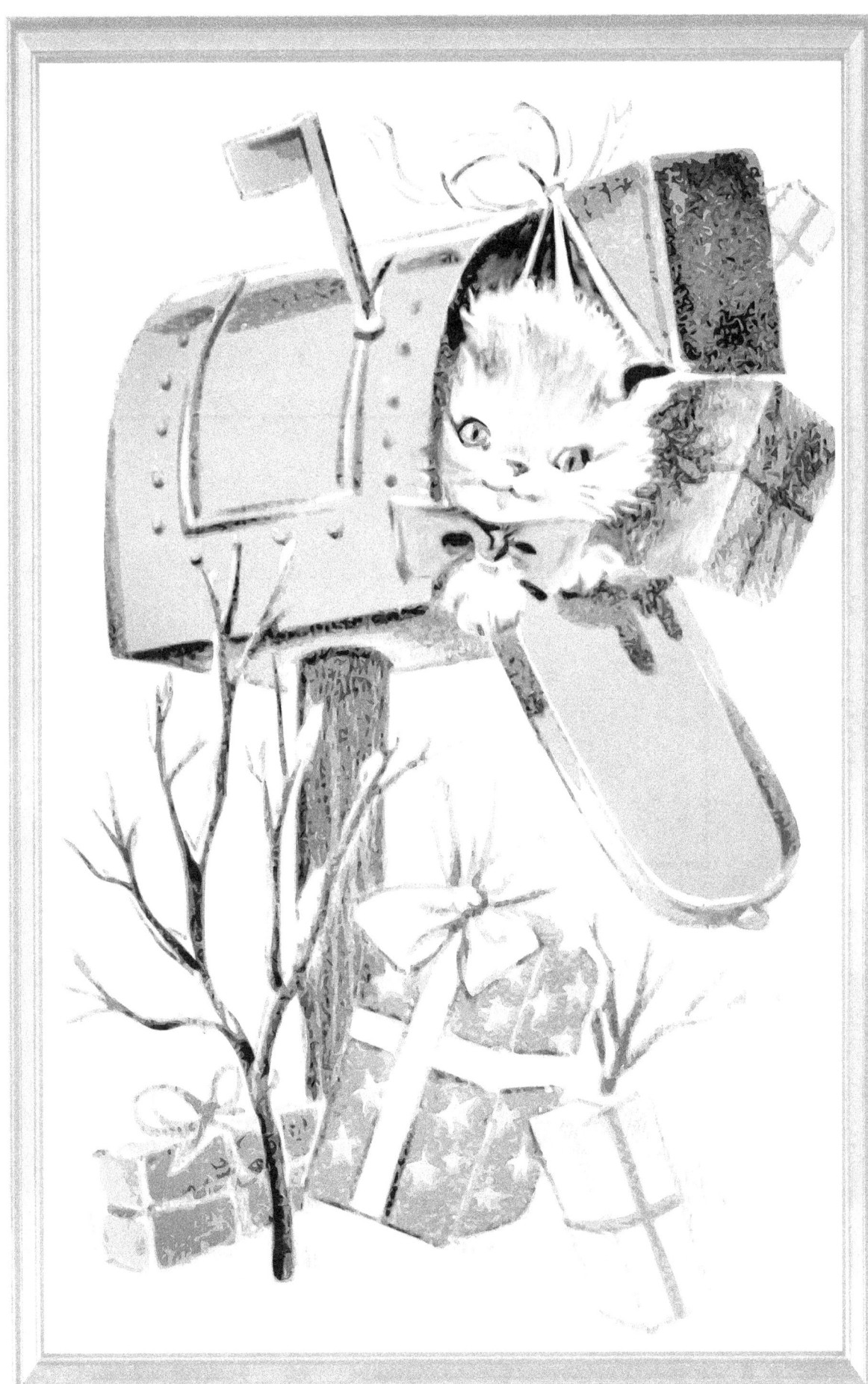

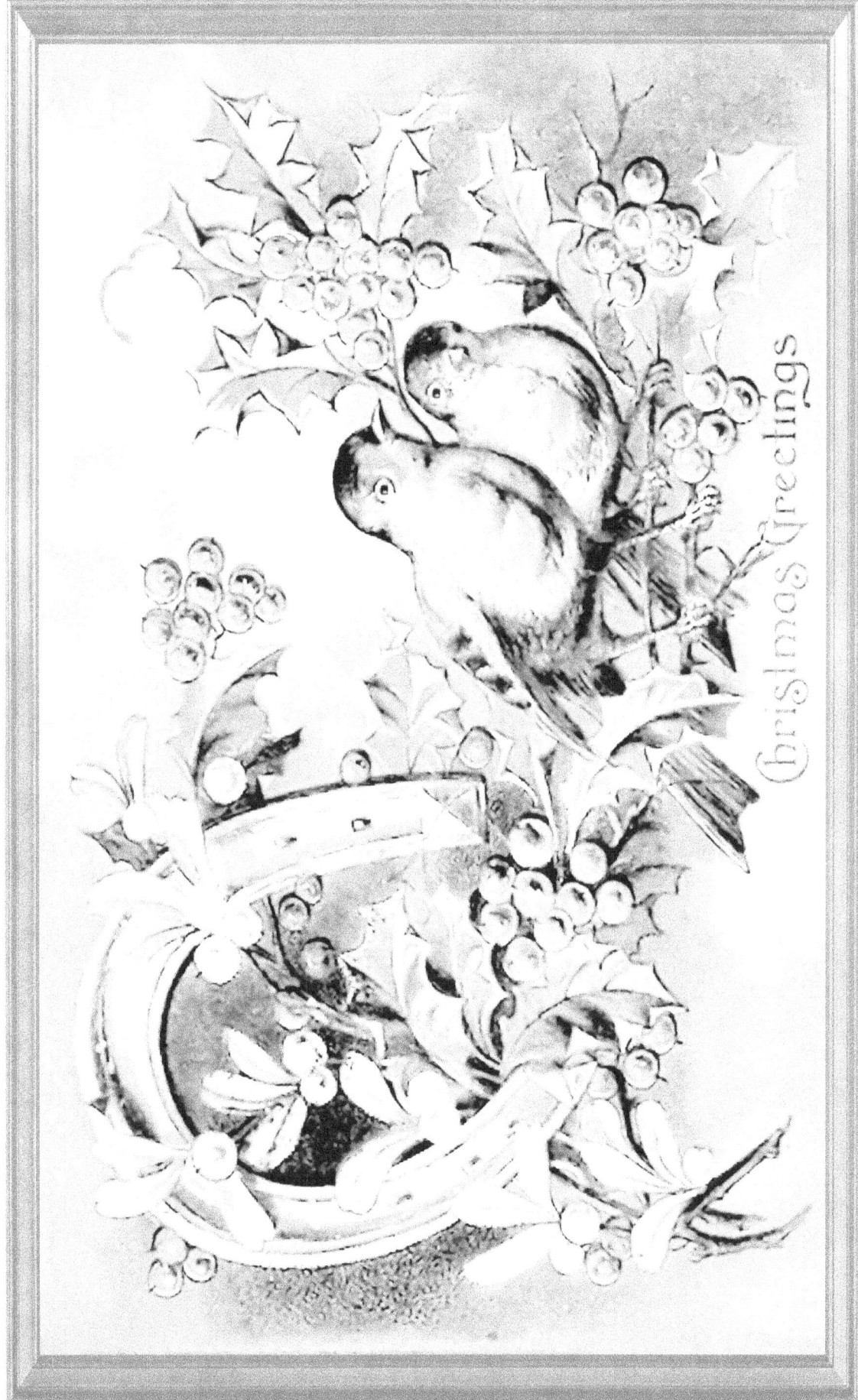

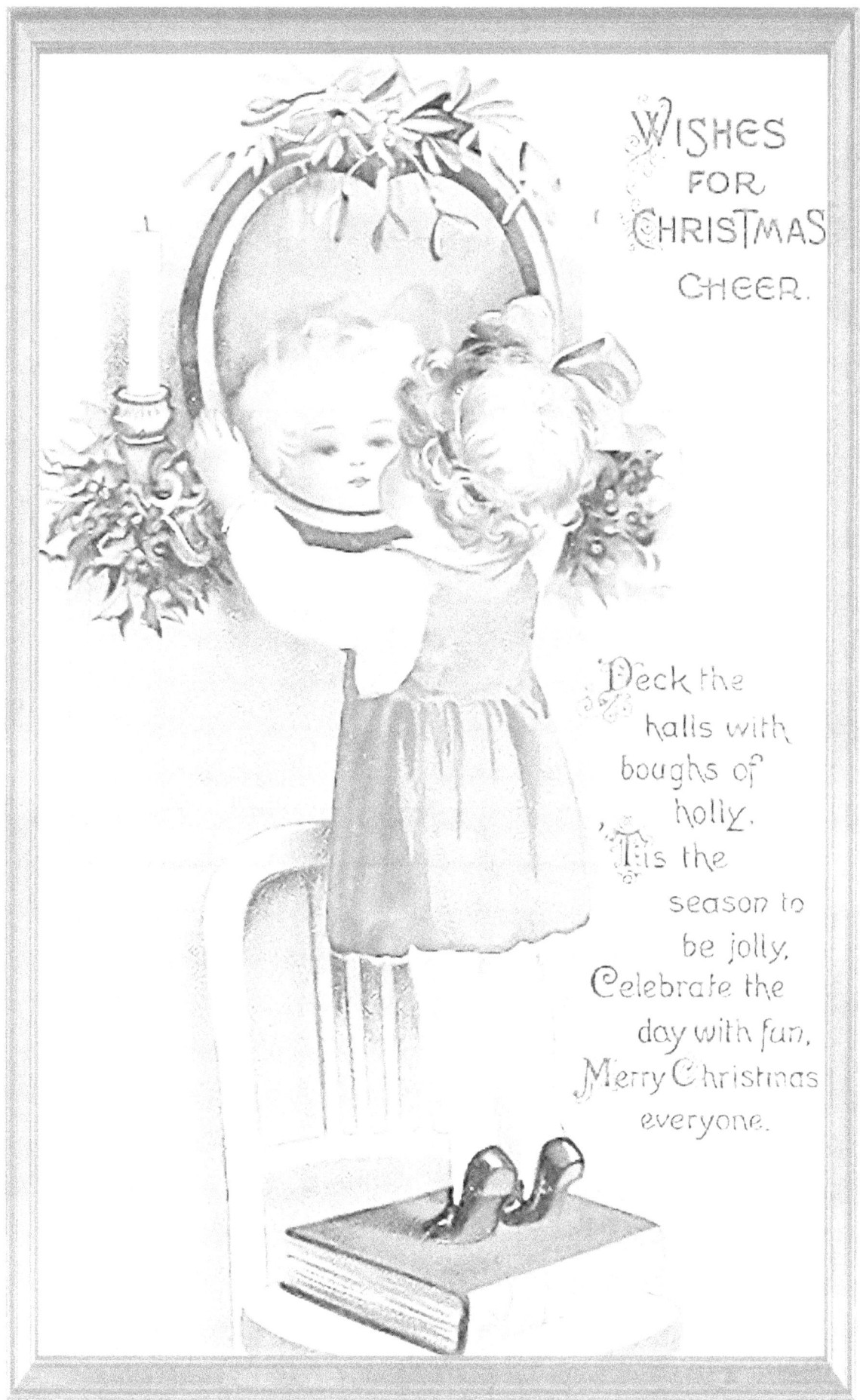

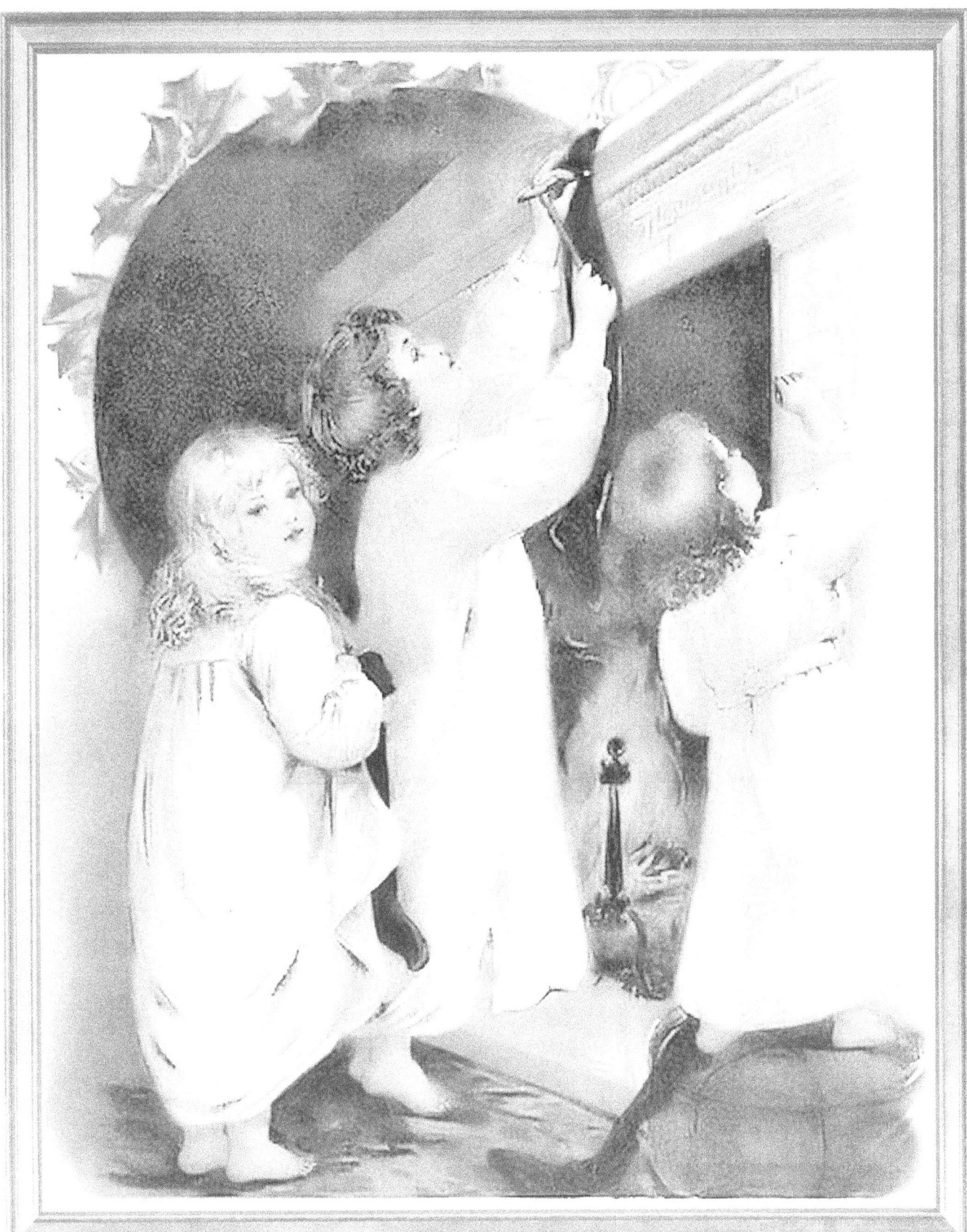

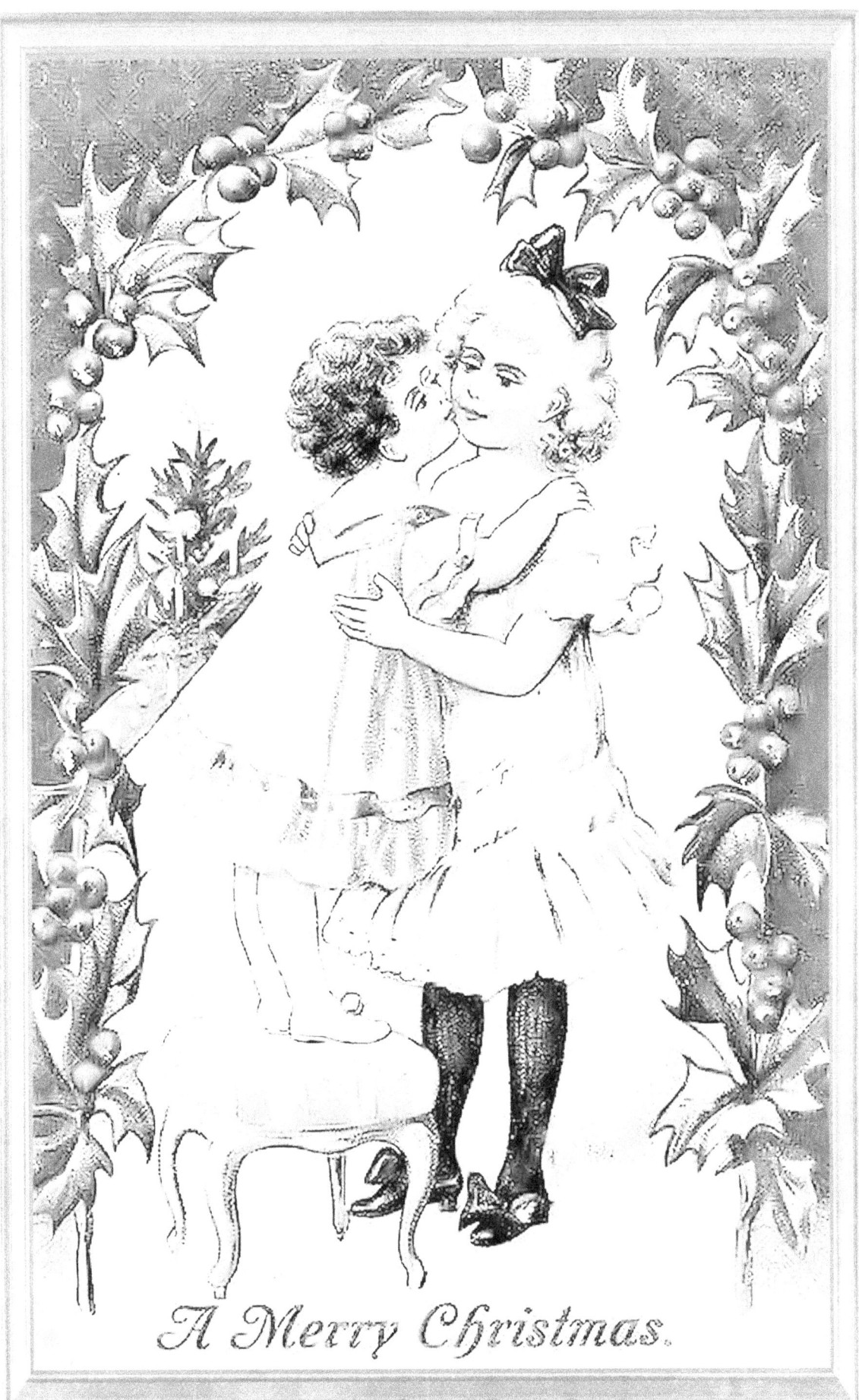

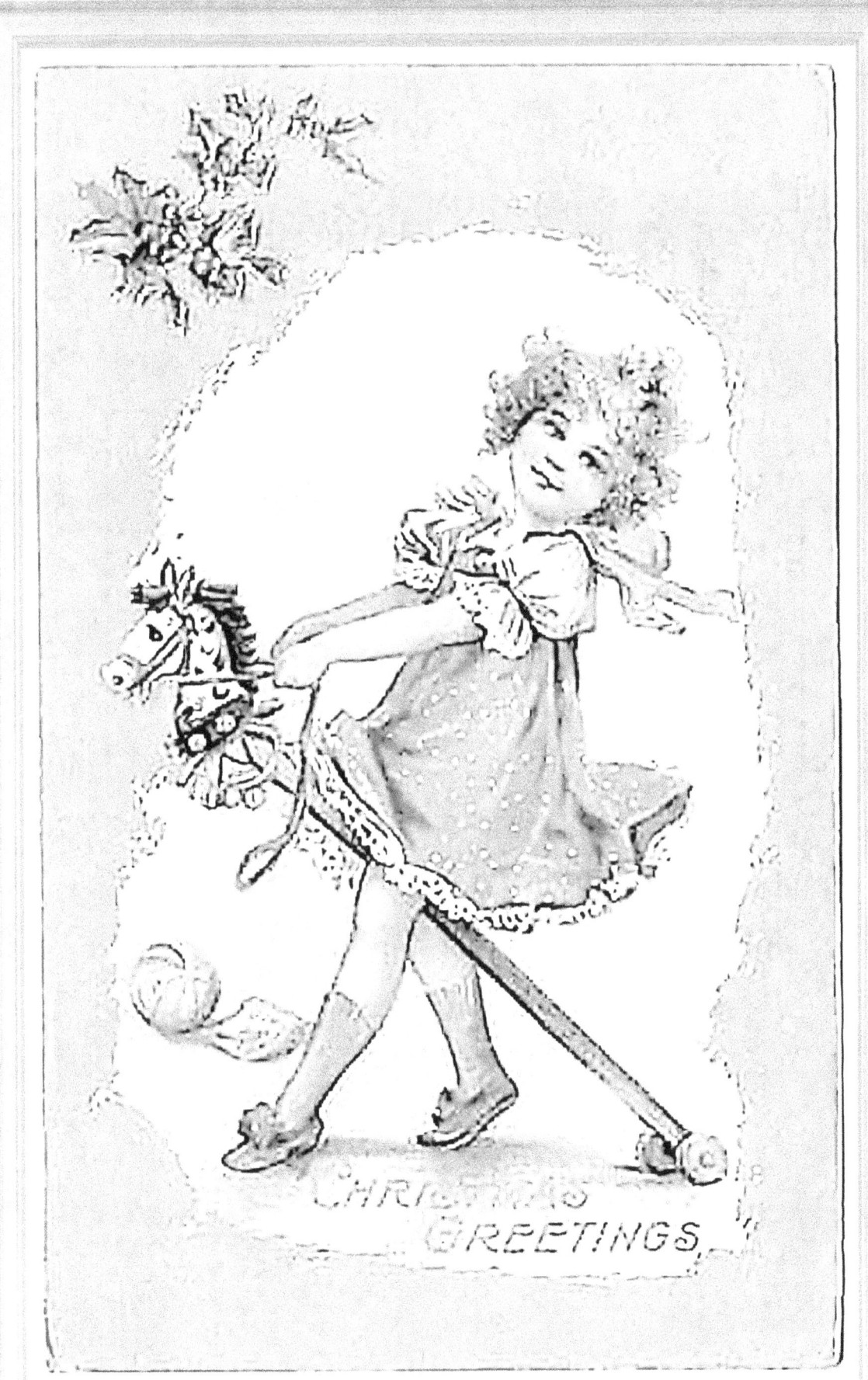

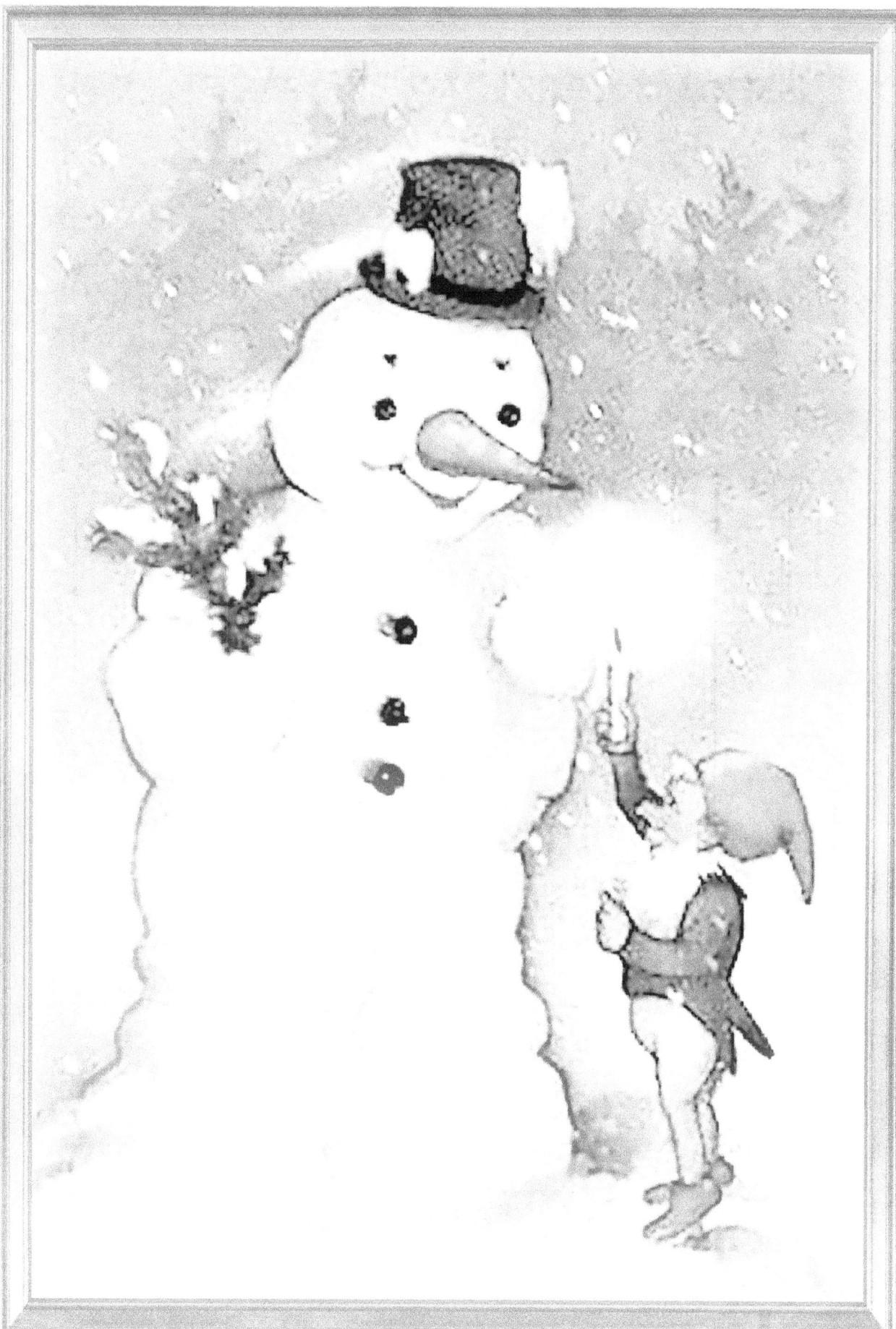

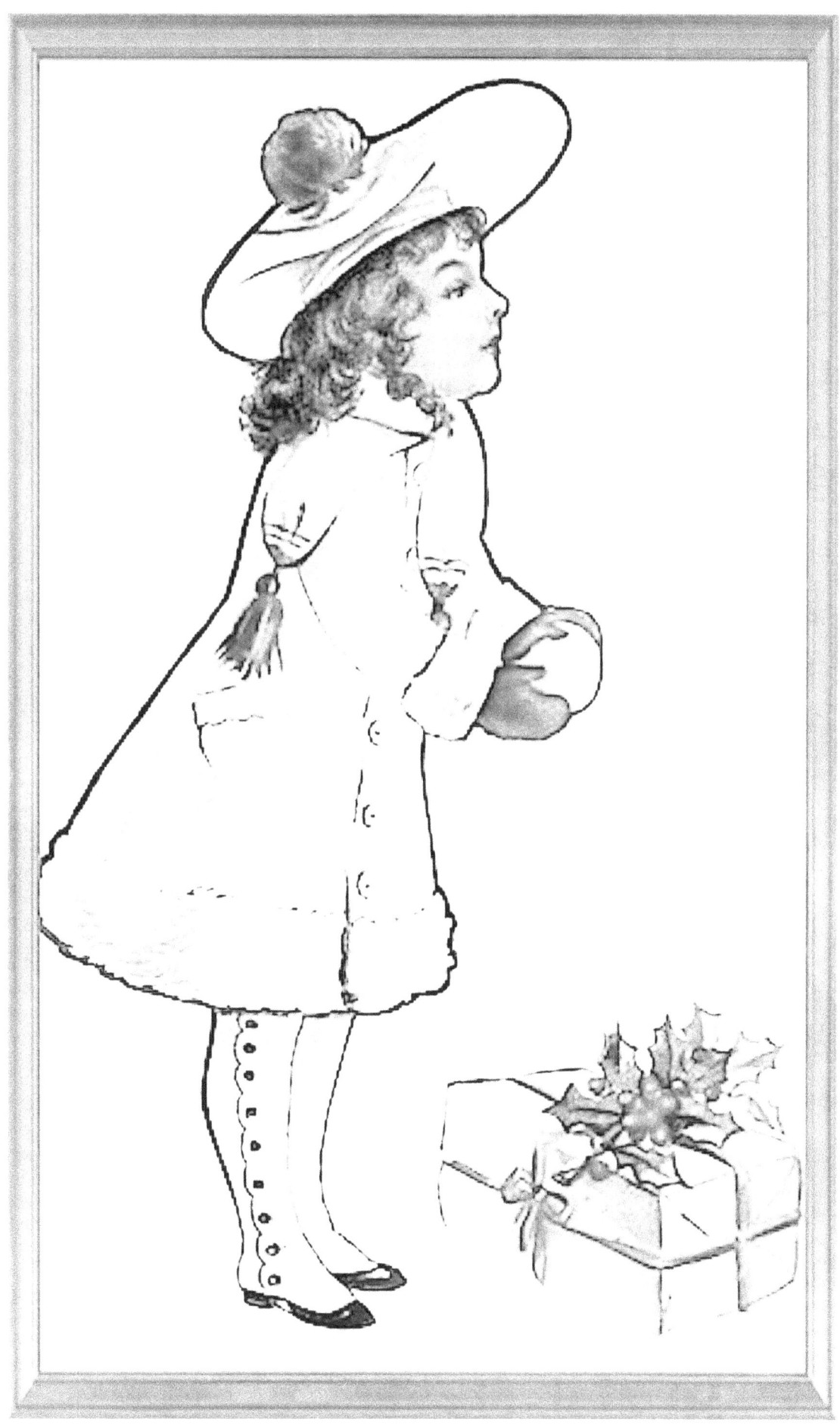

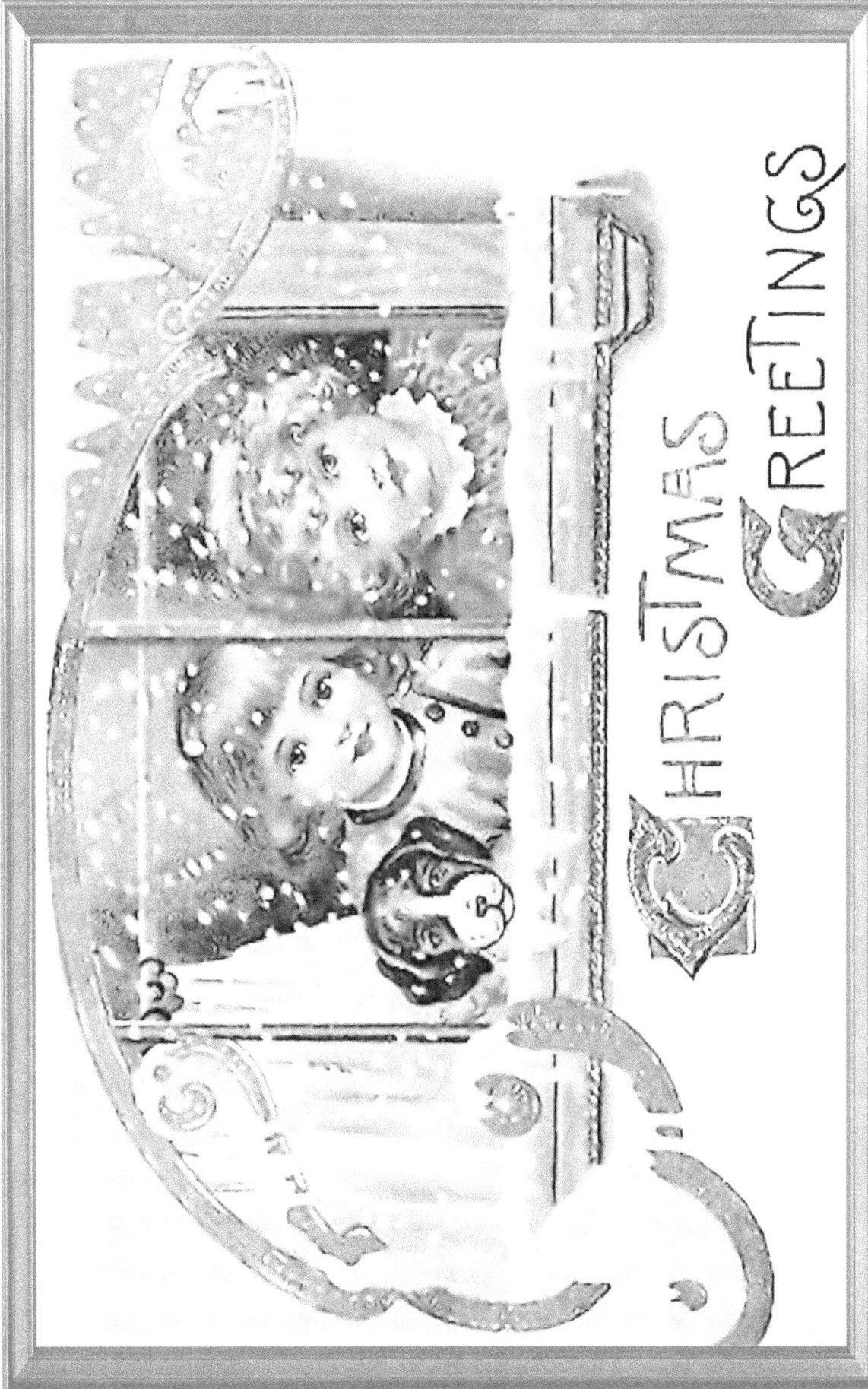

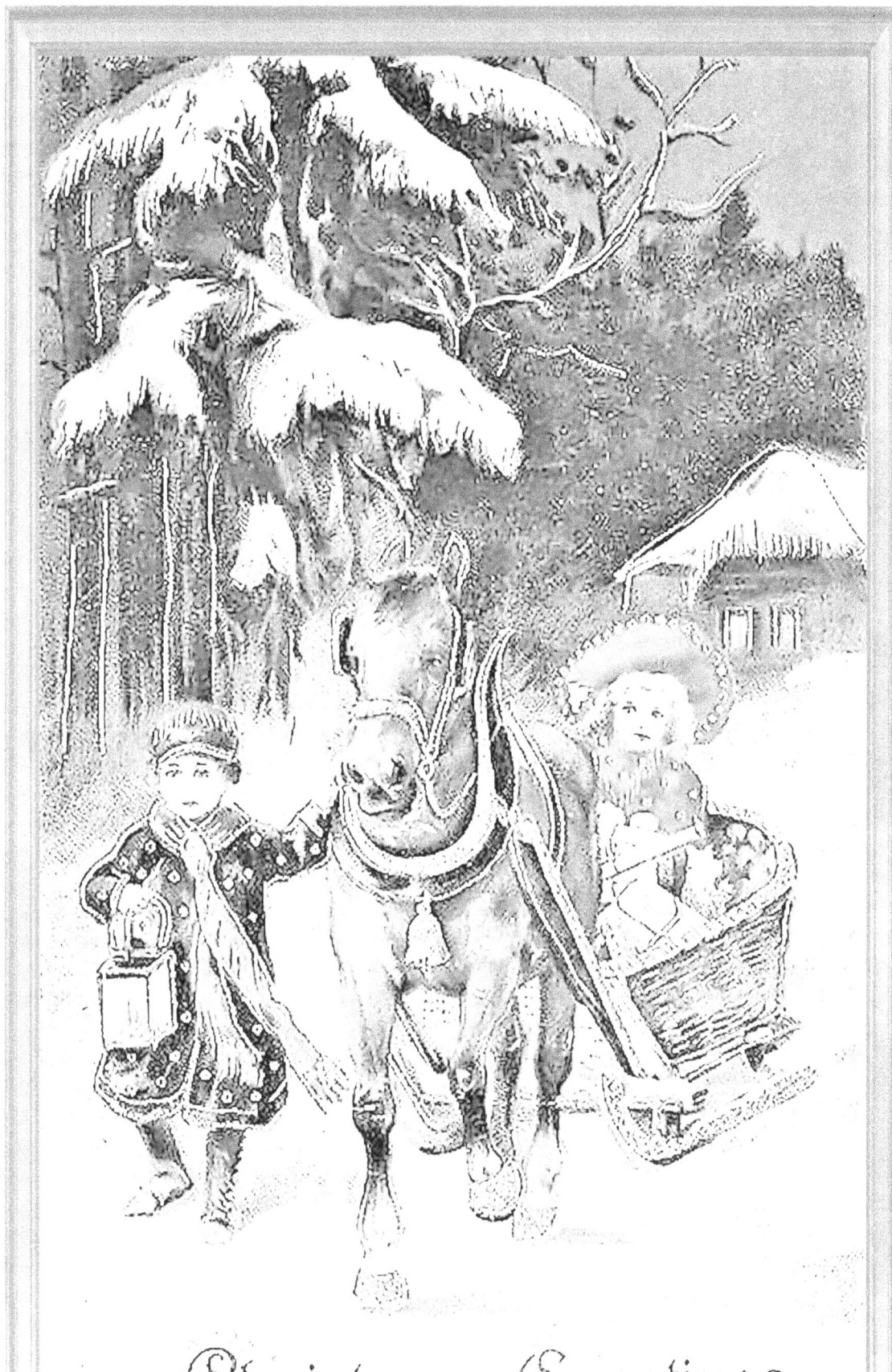

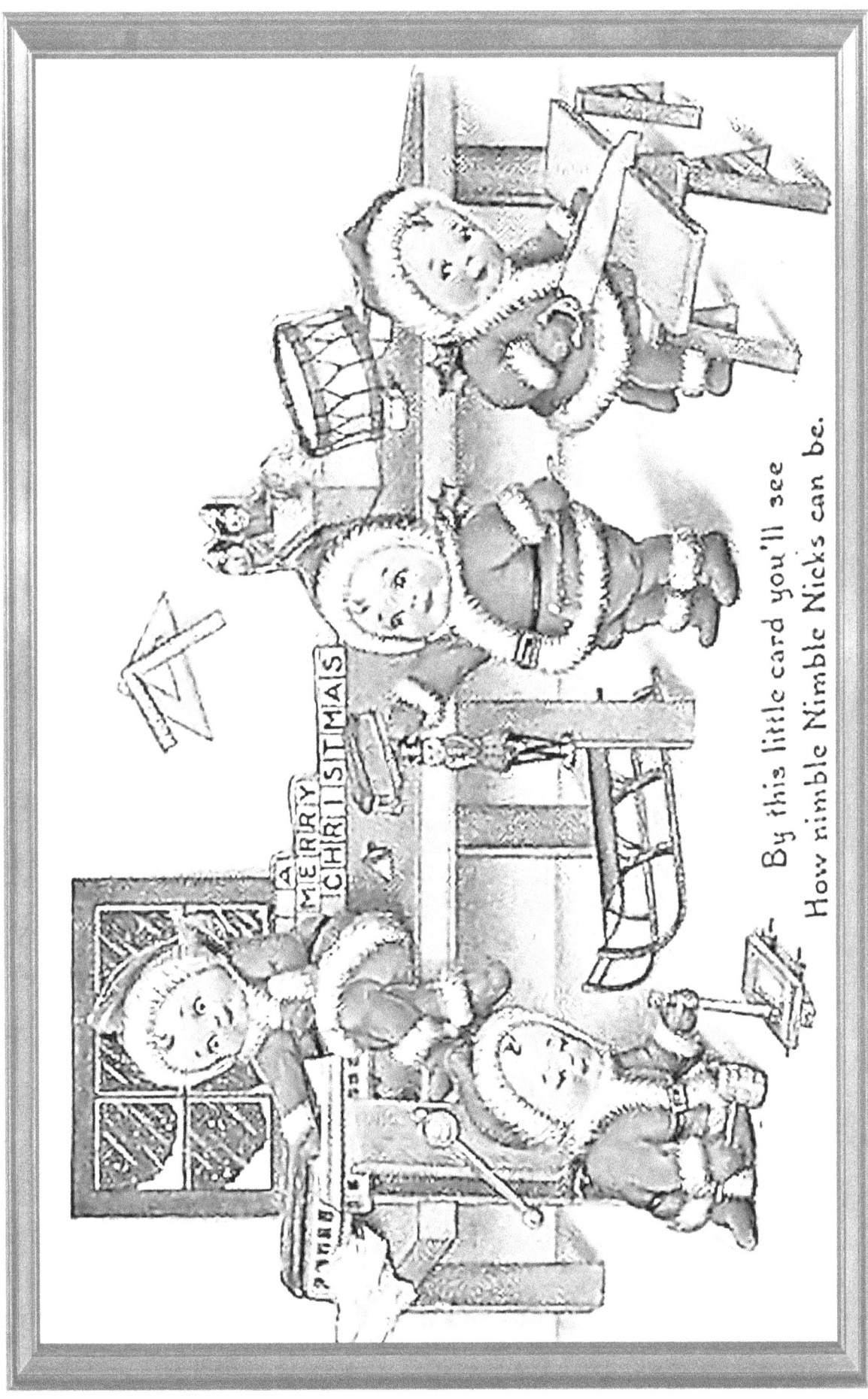

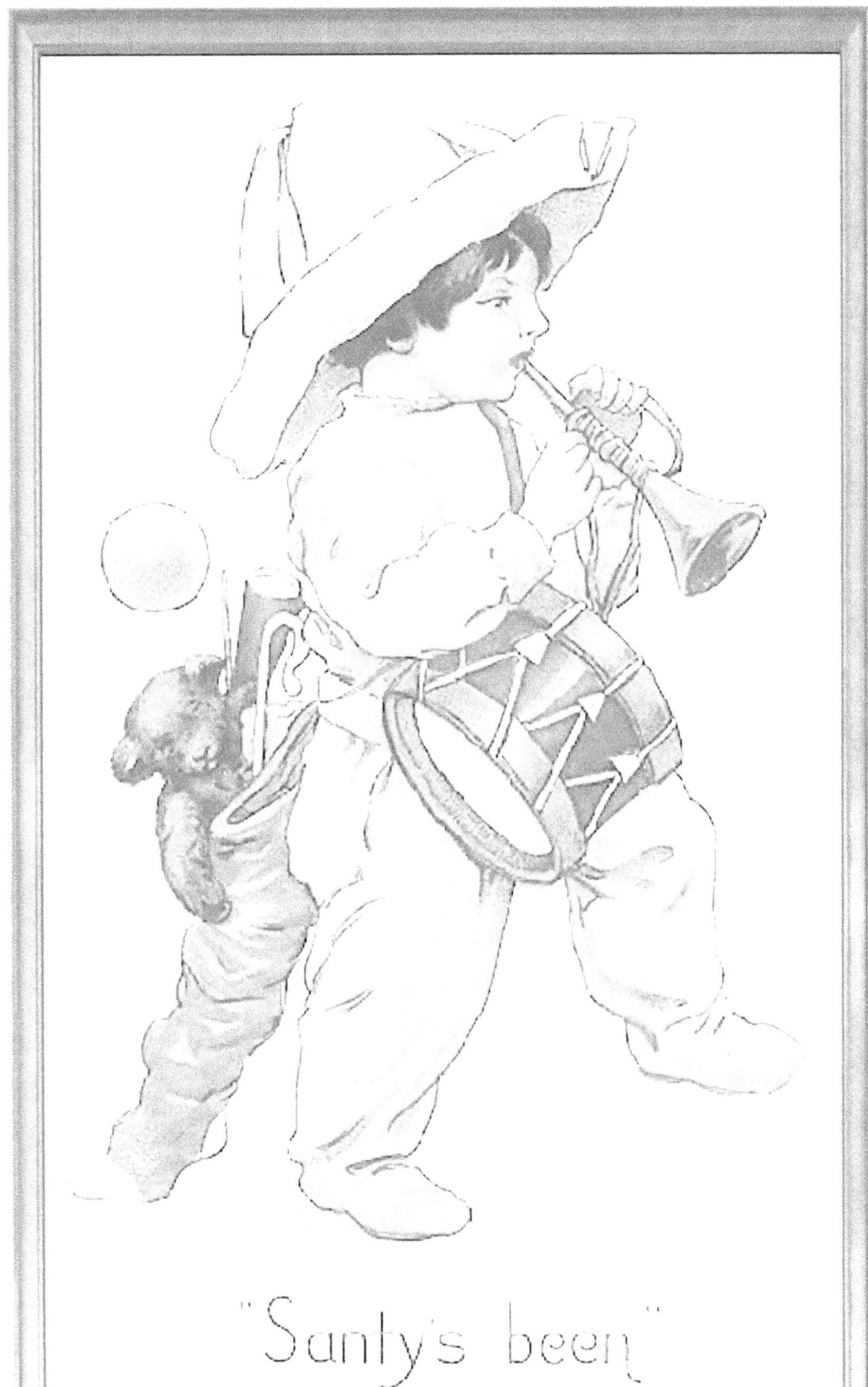

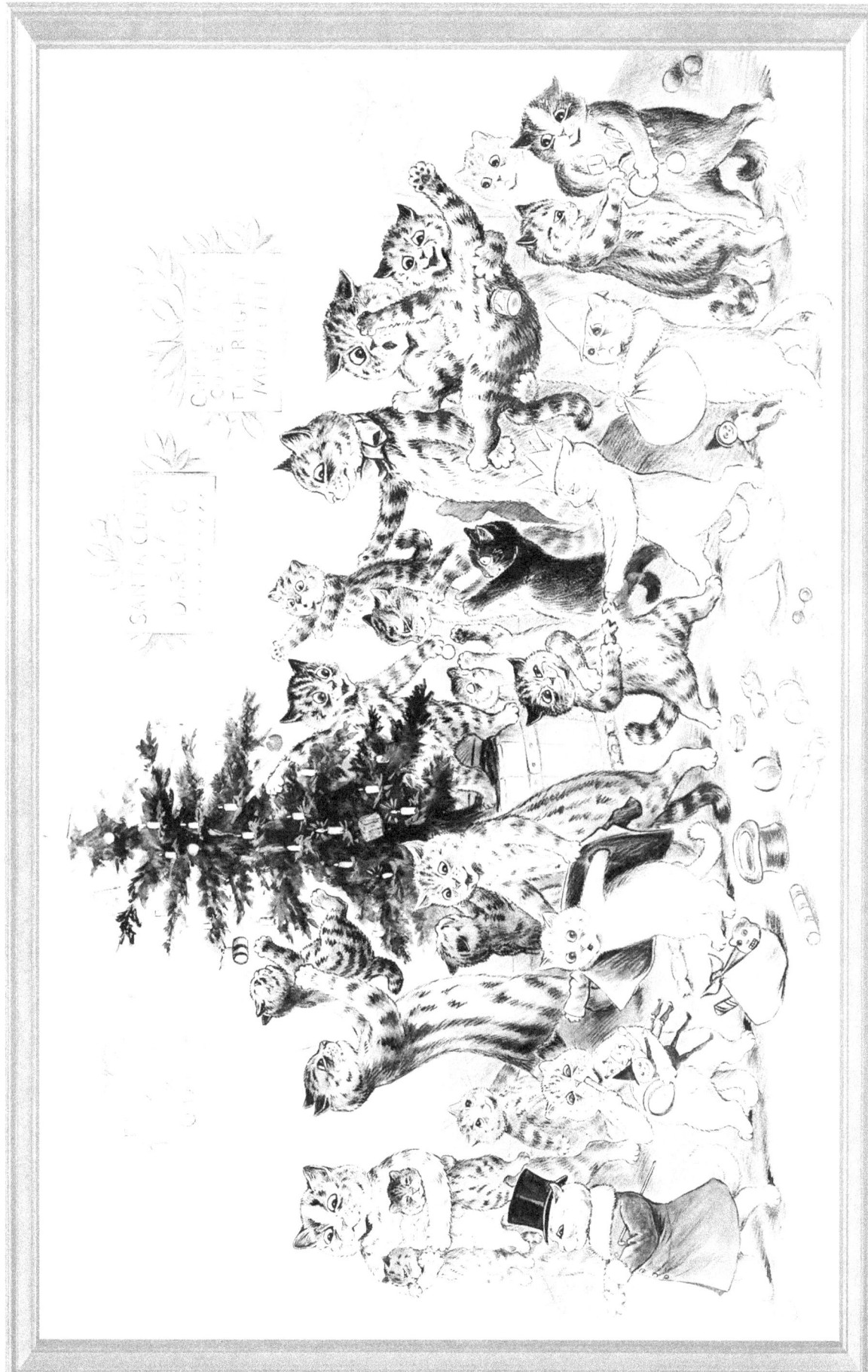

Beautiful Artwork by:

Completion Date:

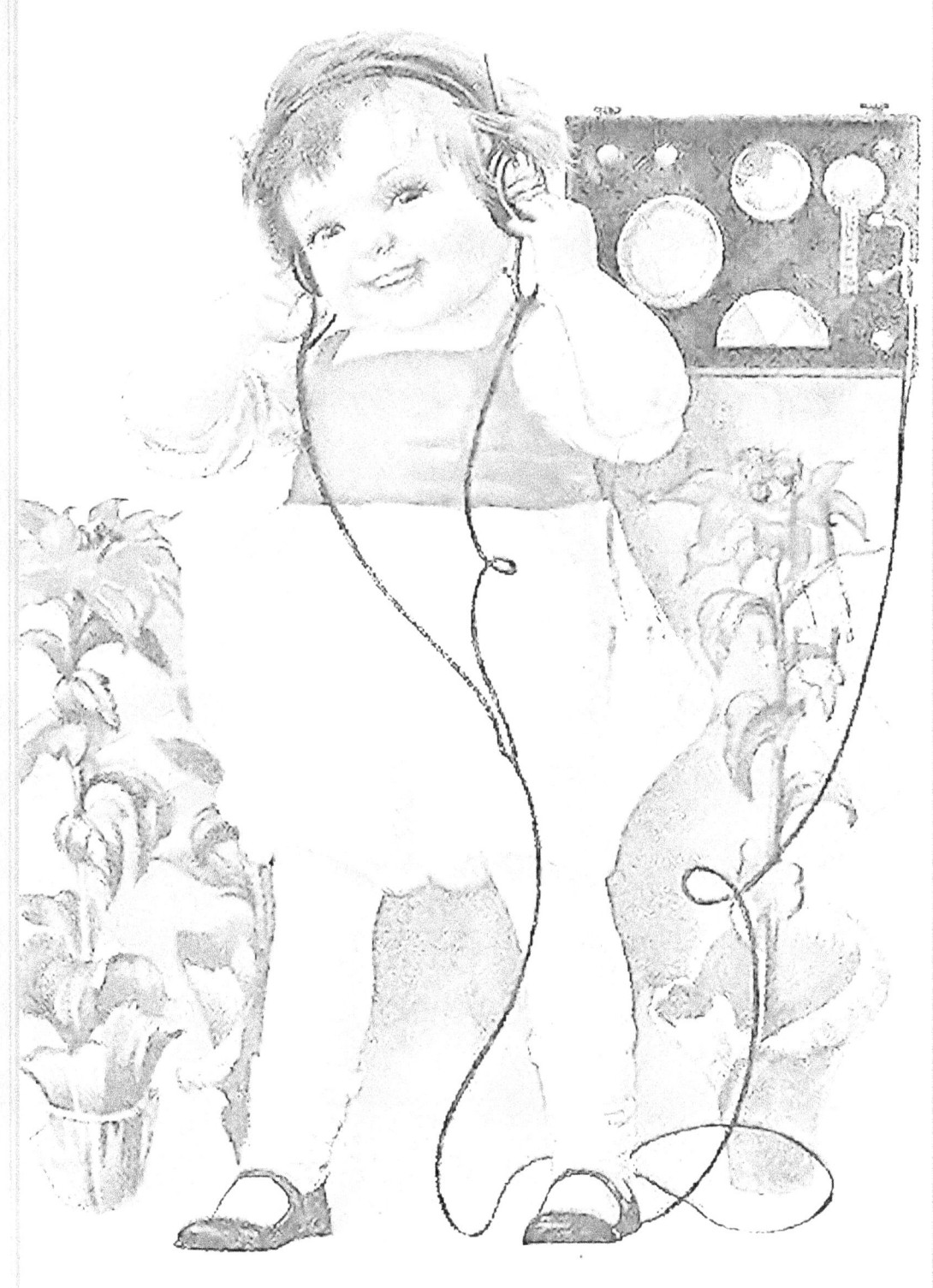

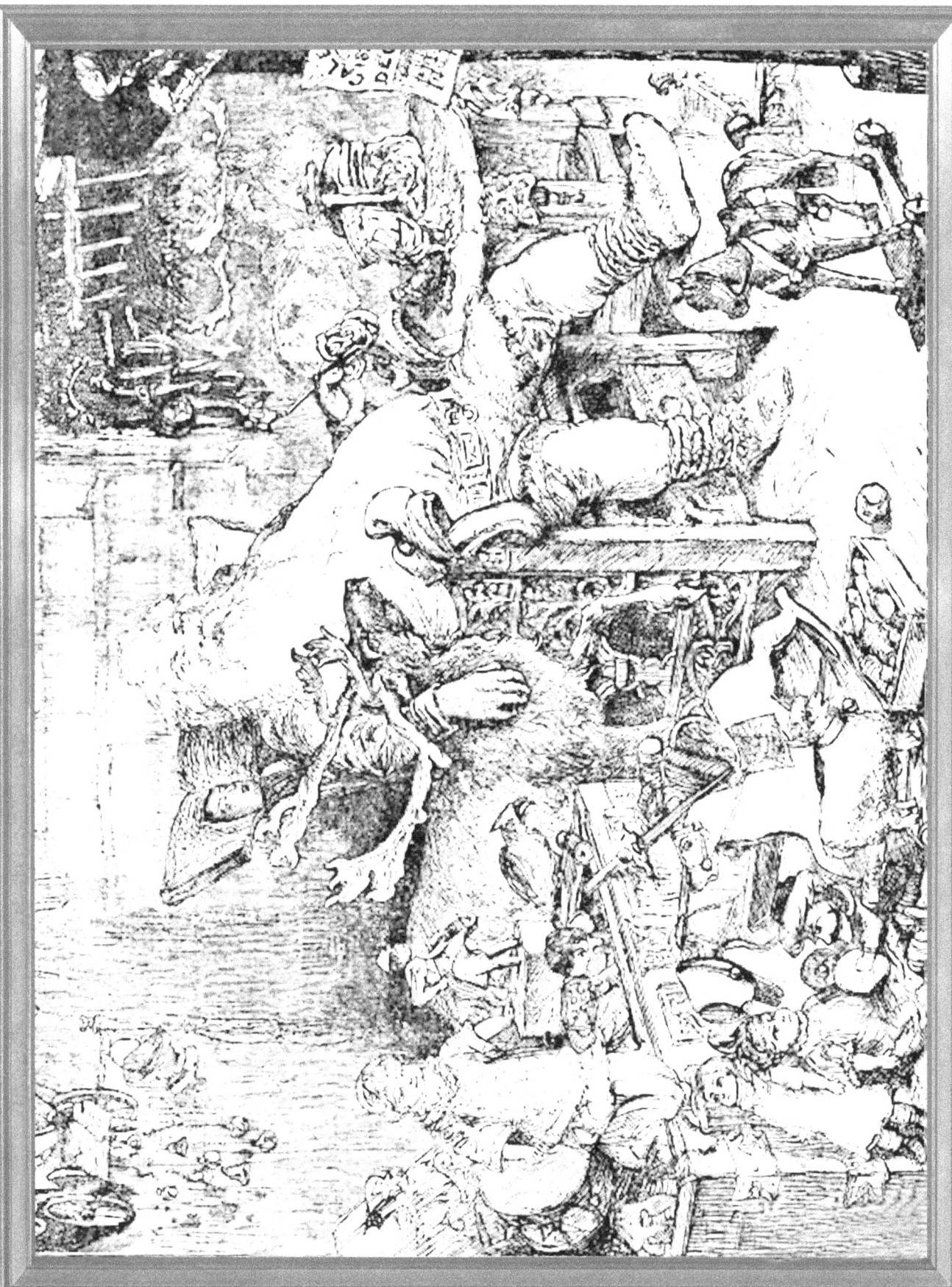

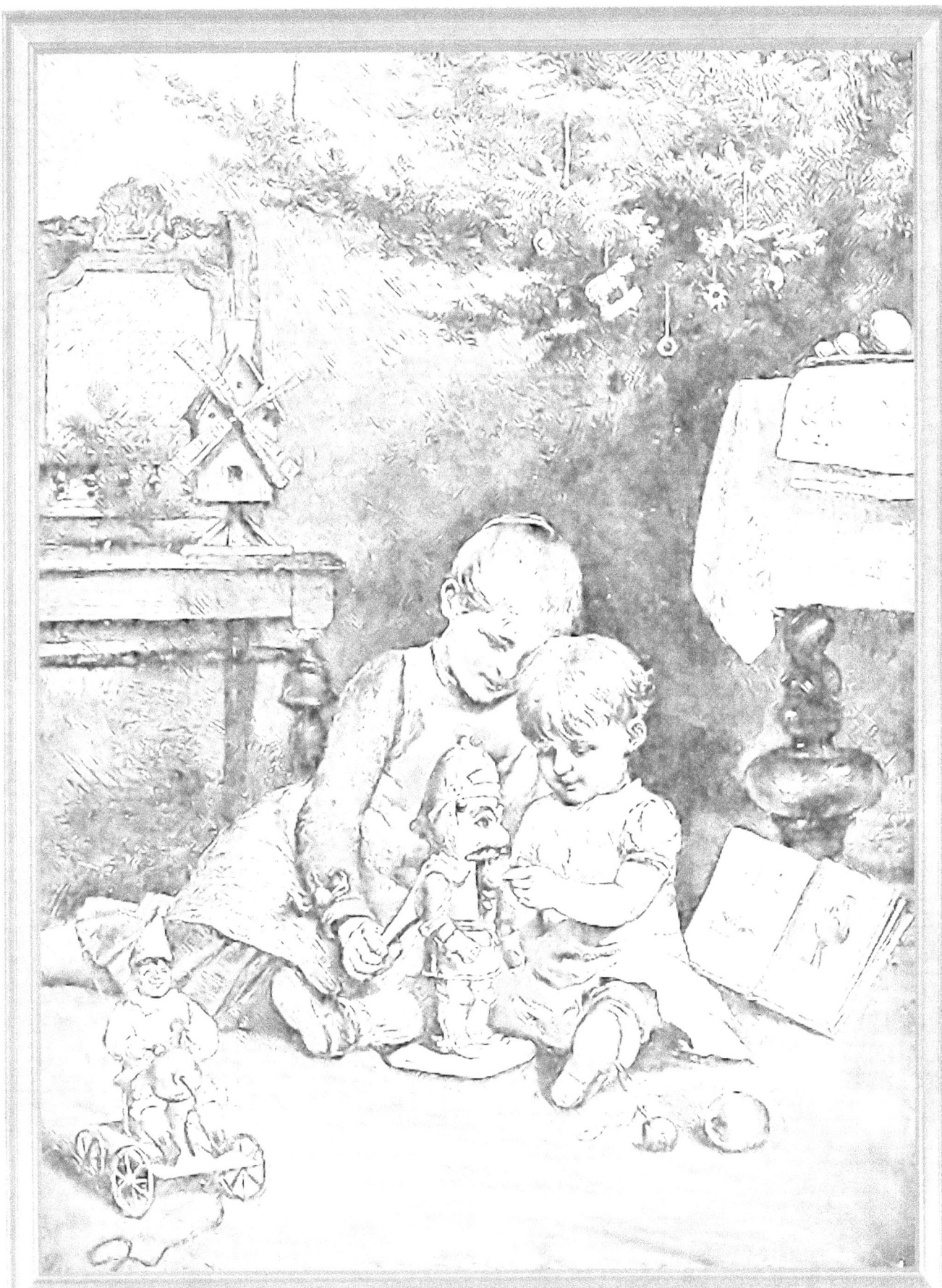

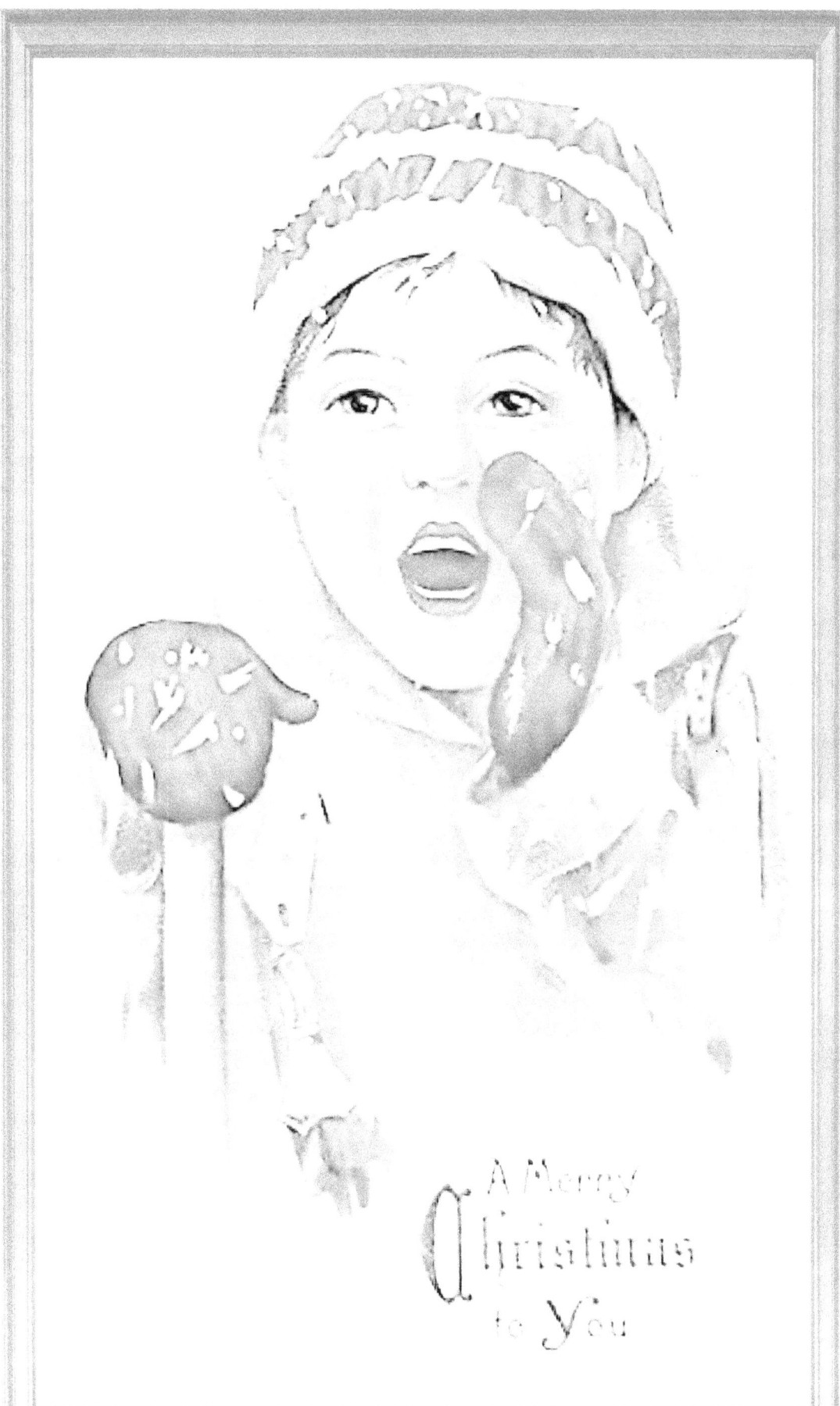

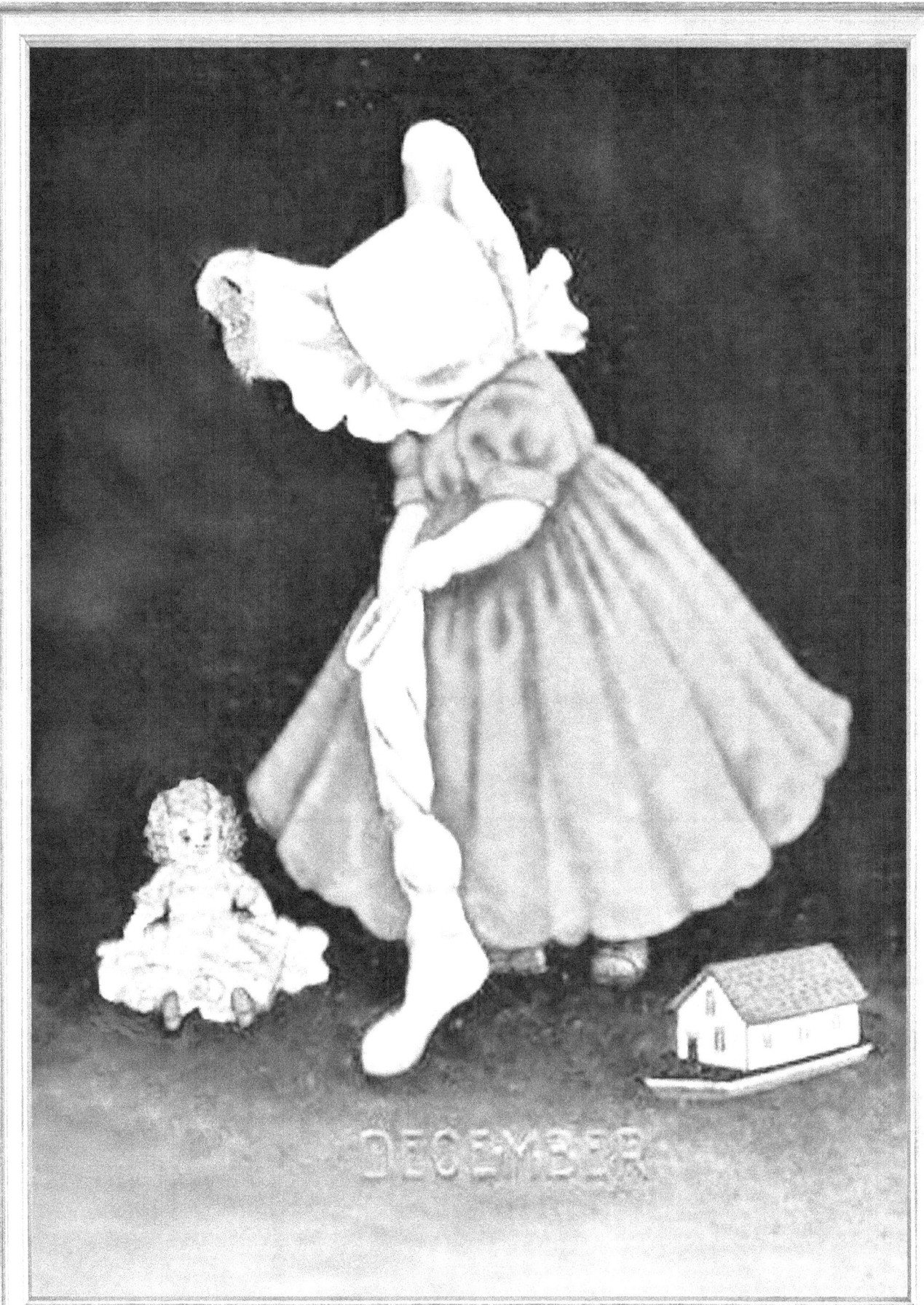

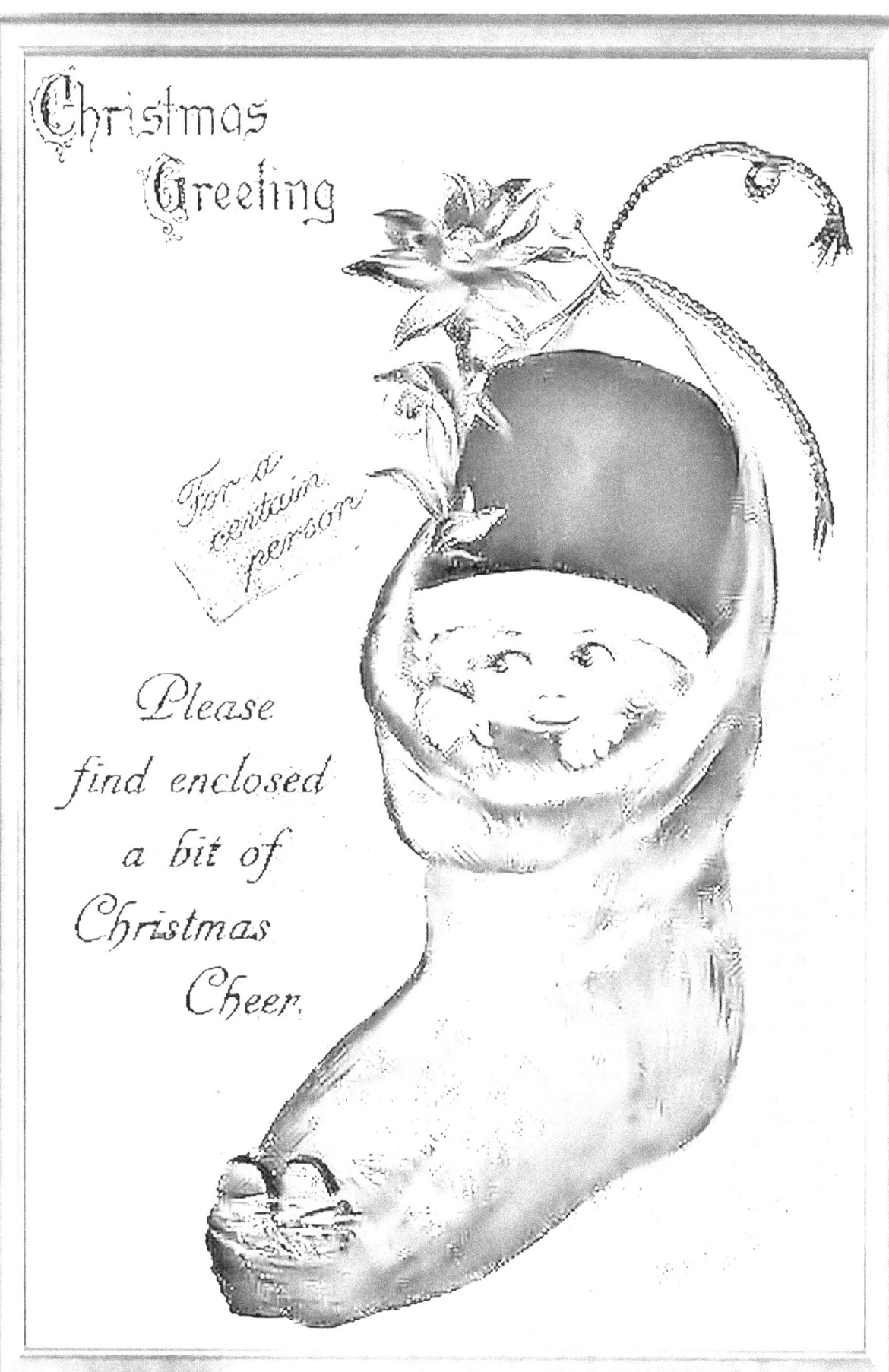

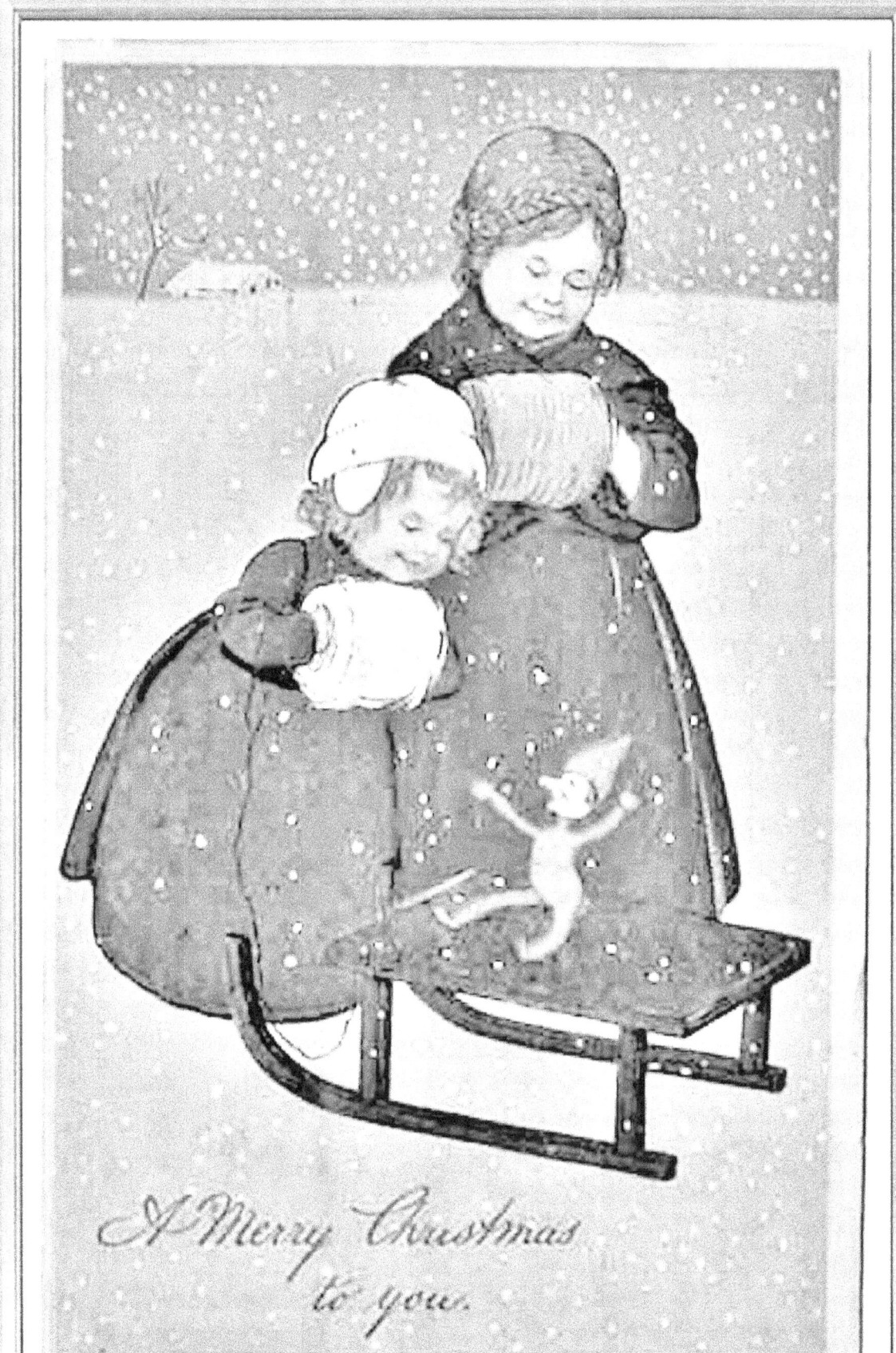

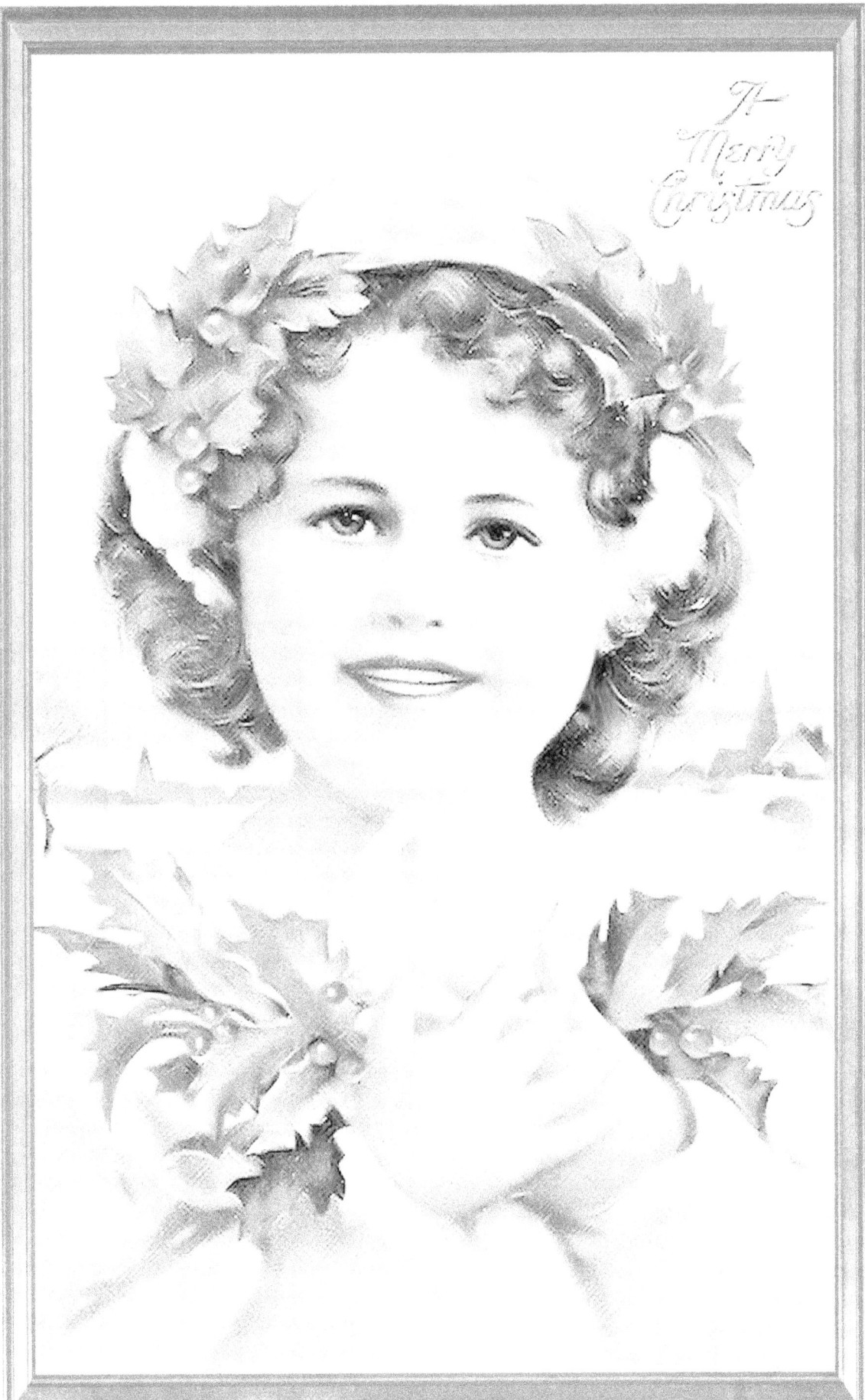

Beautiful Artwork by:

Completion Date:

www.ingramcontent.com/pod-product-compliance
Lightning Source LLC
Chambersburg PA
CBHW081615220526
45468CB00010B/2886